DURHAM
TALES

the morris street maple, the plastic cow,
the durham day that was & *more*

JIM WISE

THE
History
PRESS

Published by The History Press
Charleston, SC 29403
www.historypress.net

Copyright © 2008 by Jim Wise
All rights reserved

Cover design by Natasha Momberger

First published 2008
Second printing 2009
Third printing 2011
Fourth printing 2011
Fifth printing 2013

Manufactured in the United States

ISBN 978.1.59629.588.9

Library of Congress Cataloging-in-Publication Data

Wise, James E., 1949-
Durham Tales : the Morris Street maple, the plastic cow, the Durham Day that was, and more / Jim Wise.
p. cm.
ISBN 978-1-59629-588-9
1. Durham (N.C.)--History--Anecdotes. 2. Durham (N.C.)--Social life and customs--Anecdotes. 3. Durham (N.C.)--Biography--Anecdotes. I. Title.
F264.D8W57 2008
975.6'563--dc22
2008040208

For Elizabeth and Ben,
our children, for whom Durham always will be, in a way, home.

At thirty, a man suspects himself a fool;
Knows it at forty, and reforms his plan;
At fifty chides his infamous delay,
Pushes his prudent purpose to resolve;
In all the magnanimity of thought
Resolves, and re-solves; then dies the same.
—Edward Young, 1683–1765

CONTENTS

PREFACE

To begin with, these are some stories from a town in the Sunbelt: my town, our town. Not *the* stories, certainly, for to tell them all, as the definite article implies, would fill many volumes. By the time those were complete, there would be more tales to tell, more perspectives would have appeared and other interconnections would call for explication. Besides, all stories are renewed each time they are retold, and these are not told here for the first time—just told here in this particular order, with this particular selection and with these particular words. In this way, as retold in the late summer of 2008, they perhaps compose one particular larger story, and leave one particular impression, of one particular hometown place.

It must be said that the particular impression these stories make will be, for the most part, in the particular minds of particular readers. As such, those impressions will be influenced by others' impressions and recollections of many particular hometown places of the readers' own. They may also be colored by some abstract notion of "hometown," in the way that Andy Griffith's "Mayberry" turned out to be hometown for every American—or its imaginary surrogate. And that's just fine.

Remember, it was no less a latter-day genius than George Lucas who, before his *Star Wars* period, demonstrated that one American place of the early 1960s could be all American places, where people navigated the cusp of adulthood—the characters of *American Graffiti* were people we all knew in high school. There is community to be found in that: shared humanity, like the boot camp stories that any veteran can get tired of hearing; the "drunkalogs" of every alcoholic; and the sense of possibility in the first day of school vacation, wide as a Western sky, such as Ray Bradbury tapped to make one particular hometown place *all* particular hometown places in his classic *Dandelion Wine*.

So, while the setting of these stories—Durham, North Carolina, United States of America—is a particular place, and while Durham is unique, it is not unusual. It is a town Southern by geography, but a product of nineteenth-century industrialism—railroad, automation, mass production, a global economy—and hence its history, and the "character" local boosters insist the town has, embody as much of the Northern Rust Belt and the Old West boomtown as they do of the "South" (more so, really). There is a Confederate monument on the Old Courthouse lawn, but the memorials of current civic pride are blocky, bulky brick tobacco factories and warehouses from the Gilded Age, being rapidly converted here in the Silicon Age to offices, art galleries, trendy restaurants and pricey dwelling places. Just like all over the rest of the country. One cannot say our hometown, our Bull City, our City of Exciting Stores, is not a dedicated follower of fashion, to borrow an expression from the Kinks.

And it's home, this author's home of choice for forty-something years, a homeplace he has also observed and chronicled in journalistic capacity for more than half that time, the hometown where his children were born and grew, through school, youth-league sports, scouts and church, while their surrounding grownups grew along with them. Everything unique, and everything remarkably similar.

Being a Sunbelt town (and totally unlike a "Southern" town), most of the people one meets in Durham are fresh off the boat from somewhere else, typically somewhere East or North, but sometimes even from the Pacific Rim. Inevitably, hearing of our duration here, they say something like, "You must have seen a lot of change." Yeah, there were about 80,000 people when we arrived in 1966, and about 250,000 now; there are more roads and stoplights and eating places that used to just sell food but now serve up dining experiences. Fewer work shirts, more suits.

When we write "our town," we mean its surroundings, too, even those not yet so citified and in tune to the way things are according to the leading, or most televised, authorities. "Durham" still has its countryside. Our town, itself, occupies just more than a third of our county, and its stories are hardly confined by the city limits—much as it may seem sometimes to some people deep inside them. A county was here before a town was, and people were here a long, long time before either one—ten thousand years or so, according to current estimates. For that matter, worms have everybody else beat by a country light-year—some time back, a geologist found some of their remains here that were 600 million years old. Second-oldest fossils ever found, at the time.

The northern part of our county, up toward Virginia, is rolling and hilly, almost to the point that in a few places you can kid yourself that you're in the high country, though the county's highest point is a mere 730 feet above sea level. To the south and east, though, it stretches out and drops all the way down to 230 feet in a swamp not far from Chapel Hill. The hilly ground is part of the Carolina Slate Belt; the rest is called Triassic Basin. Around Penny's Bend on the Eno River there's an anomalous patch of soil that favors plants that belong in the Midwest prairies; in steep and shady spots, you can find mountain laurel.

Out in the county you can also find places with curious names, the ones you have to get from old-timers or a county map from a highway department. Down south, there's Few—renamed for a Duke University president after Pearl Harbor made the original name, Oyama, seem a little inappropriate. Up north, there is Bahama (pronounced B-*hay*-mah), for the founding Ball, Harris and Mangum families, adopted when the railroad came through and declared that "Hunkadora" was no name for a depot.

So, in this homeplace of flux there are enduring constants. These stories have to do with some of both. Those who have heard me talk, sat in on my classes or read much of what I have written will probably find some of them familiar. I hope that, in this new package and in these new words, they will find the stories freshened and as much fun to read as they have been for me to tell again.

No writer is an island, and so I would be remiss and downright rude if I did not acknowledge and say thanks to those who have aided and guided me along the way. First to my wife, Babs, who gave me a do-you-know-what-you're-getting-yourself-into look when I mentioned I had this project in mind but has so far refrained from "I told you so."

And to architects Frank DePasquale and the late George Pyne, who introduced me to and mentored me in the pleasures of Durham past. To the good folks at Duke Homestead, Bennett Place and Stagville historic sites and the Durham Public Library, particularly North Carolina librarian Lynn Richardson, for assistance and companionship over these years. To my colleagues at the old *Durham Morning Herald* and *News & Observer* for encouragement, ideas and opportunities—in particular, Mike Rouse and Jack Adams, who gave me a job interview on the first Saturday of dove season and hired me on the spot back in 1981.

And to the people of my hometown, with fondness and gratitude. I do deeply appreciate you all.

PART I

ORIENTATION

City of Durham, North Carolina: population 218,179 (2008 est.)
Durham County, North Carolina: population 257,947 (2008 est.)
Other county communities: Bahama, Rougemont (unincorporated)
Median household income (2004, county): $44,048
Location: latitude 36° north, longitude 79° west
Square miles, city: 104
Square miles, county: 299
Town incorporated: 1869
County formed: 1881
Major employers (2006): Duke University & Medical Center, 29,911;
 IBM, 11,527; GlaxoSmithKline, 5,179; public schools, 5,060; Nortel
 Networks, 2,600; Lenovo, 2,300; City of Durham, 2,289; V.A. Medical
 Center, 2,086; Research Triangle Institute, 2,003; Durham County,
 1,737
Nearby towns: Raleigh, Chapel Hill, Morrisville, Cary, Hillsborough
Driving time to: beach, 2½ hrs.; mountains, 2½ hrs.; Richmond,
 Virginia, 2 hrs.; Charlotte, North Carolina, 2 hrs.; Washington, D.C.,
 4 hrs.; Atlanta, 6½ hrs.

The Herald

Come fall, the world revives. In the mythology that informs one's bodily
rhythms, school starts back and football season opens. In fact, around
here, they both kick off in the pits of mid-August, but autumn's symbolism
somehow endures; down at the coast at the end of summer comes a "mullet
blow"—a shift of winds from southwest to north—bringing cooler, drier air

and motivating fish to bite again. Inland, the seasonal turning is often as not announced by several days' slow and steady rain, indicating that the mugginess of summer is over until next year and the mornings and the skies will sparkle for some weeks to come.

And the Morris Street maple tree turns color.

Fifty weeks of the year, more or less, the intersection of Morris Street and Fernway Avenue is a nondescript corner, historically a transition point between the central business district and a venerable residential section. For a little while, though, usually right after the equinox, it's got the brightest show in town when, weeks ahead of the other trees that grace the city's streets, a gnarly old sugar maple greets the morning with a fiery burst of orangey red.

The maple has an eastern exposure and is set off by an evergreen magnolia on one flank, a late-changing willow oak to the rear and, like as not, a clear, rich blue sky above and beyond. About go-to-work time the sugar maple catches the rising sunlight full-face. It's like the god of summer has plugged in the lights to alert us that he's off duty and there's only about one hundred shopping days left until Christmas, if you'll pardon our getting ahead of the story. Sheer, unadulterated glory.

Now, the maple tree's location may be otherwise nondescript, but it does have a story of its own. Right across Morgan Street there is a long, low building that sort of suggests a gymnasium. These days, it houses offices for the public school system, but its original function was to be a United Service Organizations (USO) club, one of four in town, entertaining thousands of fresh-faced boys training for war at Camp Butner, just up the Oxford highway.

In a later age, the building housed the draft board, welcoming other generations of fresh-faced boys to almost-adulthood and, in some cases, decisions that would determine the remainder of their lives.

On the south, across Fernway, is the Imperial Tobacco building: a British company's toehold in the backyard of the American Tobacco Company. The Brits established their presence in our town in 1903, after James Buchanan Duke—a homeboy expatriated to New York City to make himself the expansionist creator of the U.S. tobacco trust—bought a factory in the United Kingdom. Two could play in the global economy of cigarettes. Buck Duke and his overseas counterparts soon came to a gentlemen's agreement on whose turf would be whose, but the Imperial kept its foothold in Buck Duke's hometown just the same.

The maple tree grows from what was, a century and more ago, the property line between two residential lots on a street lined with fashionable homes. The street itself appears on the Blount Map, which depicts Durham

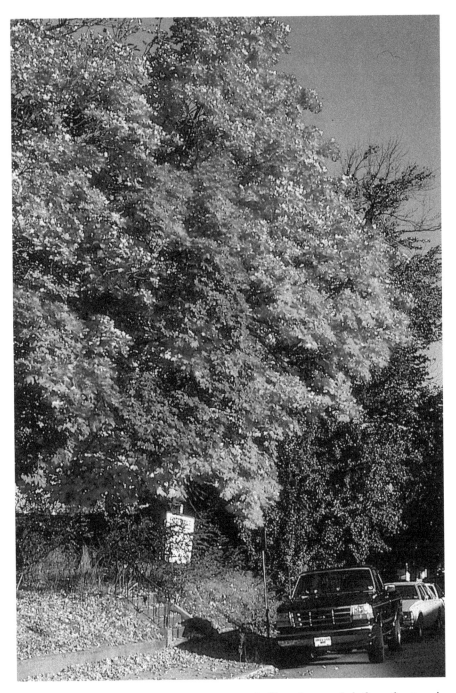

A venerable sugar maple near downtown puts on a brilliant show weeks before other trees in town turn color. *Courtesy of the author.*

circa 1867 as elderly native Lewis Blount could best remember in 1923. On the map, it is called "Mangum's Lane" and separated the farms of William Mangum and J.R. Green. It runs north from what is now Five Points, at the western edge of the central business district, and disappears after a couple hundred yards into "original forest."

By 1887, the street's name had changed and it had at least two residents—J.R. Patton and J.W. Pope—both employed at the Globe tobacco warehouse. In the next decade, Patton went on to become the town's tax collector. He held the position for about forty years and by 1897 had married a lady named Alice. City directories place them at several addresses on Morris Street until, by 1910, they settled in for the duration at 301, on the Fernway corner. J.R. Patton died in the late 1930s and Alice in the mid-1940s, and then John Scarborough, carpenter, moved in with his wife, Alma. They were gone by 1958, when the lot is listed as vacant.

By 1897, the year Pope was elected to the board of aldermen, Pope and his wife, variously identified as "Mary" and "Mollie," had set up housekeeping next door, at 303. He served as county treasurer from 1890 until 1894 and on the board of county commissioners from 1902 to 1904. The Popes enlarged their house sometime around 1905 and began taking in boarders. One of them, Allen Slater, married the Popes' daughter, Mary Frances. They remained in the Pope homeplace, Slater making his living in real estate until his death in the late 1960s. Mary Frances lived there about fifteen more years.

A plat of the Patton property drawn in 1944 shows an asymmetrical house set well back from the street, with a five-sided bay on the side toward Fernway Avenue. The "Pope-Slater" house is described in a 1982 architectural inventory as having Tuscan columns, a wraparound porch, fourteen-foot ceilings and a monumental stairway. Both houses are gone now; the corner lot is an unpaved parking lot, the one next to it overgrown. The only signs the homes were ever there are steps at the sidewalk retaining wall.

And there is the landmark tree, each year heralding the change of season. The tree is a survivor. It takes, we are told, about 150 years for a sugar maple to reach its full growth, and then it can, under congenial circumstances, look forward to that many more years of maturity. Our sugar maple's circumstances have not been all congenial: its early color change could be due to stress induced when the houses were torn down, and its roots still must contend with pavement on one side and parked-car compaction on another.

And to tell the truth, the tree shows that it has had a hard life. Some upper branches are dead, others look sickly. But a few yards away, in one of the abandoned homesites, an offspring has taken root and grown. There is hope that autumn's show can go on.

THE ICE MAN

Late in life, Tom Phipps would say he never had any thought about living anywhere other than Durham. Not ever in ninety years. He said he just fell in love with the place as a boy and still felt the same, even though, by the time he reached his ninetieth birthday in 1996, the Durham he had known was gone.

"Ain't no more Durham," he said. He was not bitter, just a little sad. There had been a time when Tom Phipps knew every street in town intimately. But they all changed. Everything moved to the outskirts that had once been faraway fields and woods.

Phipps came to Durham in 1915 when he was nine years old. By horse and wagon, his family moved the twelve or so miles from Chapel Hill, and the first things they saw were tobacco warehouses. The family took up residence just across the street from one, and in old age Phipps remembered the streets choked with farm wagons hauling the yellow crop to market. He remembered the soldiers who trained in the warehouse with their wooden rifles, preparing for great adventure in the Great War Over There, and he remembered November 11, 1918.

"All at once, I heard whistles blowing, horns blowing on cars, people hooting and hollering." Men were up on the roof of the Seaboard warehouse, and the factory whistles cut loose with their bull's bellow and Indian whoop.

"The war was ending," he said. But joy was brief. The same autumn that brought Armistice Day brought the great flu. The epidemic closed Durham's schools, and Phipps went to work delivering prescriptions. When he made some of his deliveries, the customers were too weak to answer his knock. "Sometimes, next thing you'd hear about them, they were dead."

Not everything was bleak. Phipps would spend time with the horses at the fire station and Howden Funeral Home uptown on Mangum Street; coming from the country, he liked animals. And there was Lakewood Park at the end of the streetcar line, with its swimming pool, roller coaster and diving horses. The owners advertised it as the "Coney Island of the South."

There was Jerry Markham, the former slave who operated a crossing gate and lived by the tracks. If you got cold walking to school, Markham would let you come into his house and get warm. There was the big, eighteen-inch snowfall: "It lasted forever, looked like. Had no way to clear the streets or anything. That was the year Lindbergh flew the Atlantic, 1927."

In those days, the town ended at Maplewood Cemetery. There were five banks uptown and a livery stable between Main and Chapel Hill Streets,

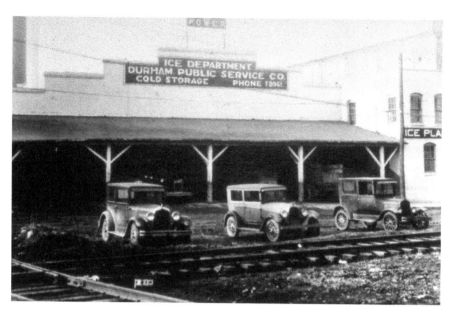

Public Service Company ice plant, about 1920. As a boy, Tom Phipps sold ice around town during the summers. *Courtesy Durham Public Library.*

right where Belk's would build a department store one day. Where those streets crossed at Five Points, there were five hot dog stands around the area. Amos 'n' Andy's was the best. "Go in there and sit down on a Co'-Cola crate in a back room, you might be sitting next to a bank president."

Hot dogs cost a nickel, six for a quarter. A bath at the barbershop would run you a quarter, and a shoeshine was a dime. Phipps sold ice in the summer. On a good day he could move maybe fifty blocks, and after the first ten he got a quarter's commission on each. Come winter, he sold coal off the back of the same wagon, but if a warm spell came along he might put in a week's labor and have but seven dollars to show for it.

Electric refrigerators killed the ice business. Phipps became a bus driver, then a mechanic. He retired in 1974 and became a fixit man and carpenter. He lived with his son out on what had been the town's outskirts. While he wished Durham could be like it was again, he knew that couldn't happen and it really didn't make much difference to him. "This world isn't my home anyway. I'm just a stranger passing through," he said, but all in all he had had a pretty good run.

"I guess I'll have a little bit more with me when I go than I came in with," he said. And laughed. "I figure, I'll have a suit on."

THE WEEKEND THAT WAS

It was just one of those weekends.

Thanksgiving 1903.

Way back then, in the good ol' days their very selves, it would be years and years before *A Charlie Brown Christmas* was a germ in anyone's imagination (the cursed Red Baron was still more than a decade from takeoff), much less anybody fretting about the "commercialization" of the holiday. "Consumer culture" was decades away from formal recognition (people were making purchases, but back then they just thought of it as buying and selling). Still, hardly had Thanksgiving dinner been rendered into hash and stew than the gas company was raving about the ultramodern gas range that would be just the thing for Mother's "Xmas Cooking."

Same day, a man could get a $15.00 suit of clothes for $9.75, and a lady could get a $0.40 corset for $0.23 during the "Special Sale" at Gladstein's.

Even with the advent of the most wonderful time of the year, some people just wouldn't get into the spirit of giving. The very night before Thanksgiving, somebody broke into the Standard Oil Company office and left the safe "a shattered wreck" after relieving it of $160.00 in cash and the manager's personal gold watch. Someone, perhaps the same villain, took $2.59 from the Durham Paper Box Company and "a quantity of beer" from the Hoster bottling shop.

"The police have practically no clue," the *Durham Sun* reported.

No doubt, some people weren't into the spirit of giving thanks, either.

When Will Parrott was driving his buggy across the railroad, the horse spooked and pushed Parrott and his conveyance backward—right into a train that happened to be going by right behind him. The buggy was unsalvageable. Parrott was unharmed, but Goldy Mitchell was not so fortunate. Having just arrived from up the line in Creedmoor, he failed to notice the headlight and whistle of an approaching locomotive.

The *Sun* reported, "The top of his head was mashed into a pulp and his brains were scattered around on the ground...besides he was terribly broke up."

Whether the train that did in Goldy was the same attacked by Parrott's horse was not made clear.

Our town had been able to enjoy a white Thanksgiving, as snowfall began Wednesday morning and continued long past daylight, caressing the burglars having their way with the beer, the watch and the $162.59. For another scofflaw, there was good news and bad news that night: Page Warren managed to get out of the county workhouse, where he

was doing time for stealing chickens; unfortunately, he died of exposure while walking in the winter wonderland. Those on duty at the workhouse were apparently much into the holiday spirits, for two nights later Mamie House, a familiar offender, made her escape as well and, with apparently a better sense of direction than the unfortunate Warren, reached a railroad, caught a train and was out of local jurisdiction before anybody in charge noticed she was gone.

According to the local press, "It looks like negligence."

We may only hope that Mamie was able to take advantage of the railroad's special Christmas excursion fares—or perhaps she was in on the split of that $162.59.

THE DAY THAT WAS

While particulars do change a bit with the times, some generalities stay the same, generally speaking.

It was just one of those days. Durham Day 1977. The third of November. It was cloudy in Durham, but it was festive and gay, with a holiday feel in the air. At least, that was the idea. November 3 had been decreed, by those who went in for local boosting, to be an occasion to commemorate the largely abandoned central business district's elevation to the National Register of Historic Places. It also tied in quite nicely with the "Durham First" campaign that the chamber of commerce was running to improve the city's image. It was also the 153rd birthday of the man for whom the town was named, Bartlett Durham.

And a grand occasion this official Durham Day was. In the morning, there were hour-long walking tours of the officially historic downtown— registered in recognition of its early twentieth-century commercial buildings that had survived the city's attempt at urban renewal. In the evening, paying

"Durham First" was a chamber of commerce effort to boost Durham's image and civic pride in the late 1970s.

homage to the county's rustic past or some popular notion thereof, there was bluegrass music and clog dancing in the 1926 art deco Carolina Theatre. In between, there was speechifying by very important people, and a parade complete with Uncle Sam, color guards, marching bands, antique cars, horseback riders in cowboy hats, mule-drawn wagons and street sweepers bringing up the rear. Some of the very important people wore plastic derbies to look authentically historic. Chamber of commerce CEO Bob Booth would say in later years that this was the low point of his career.

The parade made its way down Main Street beneath an overcast sky. Some people on the sidewalks watched. A little old lady pelted very important people with hard candy. The drums drummed, the drill teams drilled and Uncle Sam shook hands as the dignified entourage made its way past vacant offices, boarded shop windows, "Going Out of Business" signs and the pile of historic rubble where Belk's department store had been before it moved to the mall.

Elsewhere, life went on. At the same time the very important people were parading, a disgruntled elementary school principal was holding a shotgun on thirty-two people at the school, including the county superintendent. The incident occurred during a meeting called to announce the principal's replacement. He may have been put out that he was not invited, but he had been under a lot of pressure. His job performance had been called into question several times, and earlier that fall he got the blame when the school was found to be infested with lice.

After four hours, with assurance of future support from the captive teachers, the principal put down his shotgun and turned himself over to the authorities. His neighbors said they'd thought he was a fine man. His wife signed commitment papers. The principal was taken to Duke Medical Center, where, later that day, a man dropped off his wife for a mental evaluation and, when he came to pick her up, found her also brandishing a loaded shotgun. Police took her back for further evaluation.

A city council candidate running on a platform of open government was accused by a rival of covering up the disappearance of $700 from the vice squad's expense fund. A tobacco warehouse owner announced that the Durham market would probably close early that year due to declining prices. An African American city councilman said he was disgusted by the lack of black faces among the very important people downtown.

"This is a special day for Durham," said historian John Flowers, who did most of the work getting the National Register stamp of approval.

In some ways, it was indeed. In other ways, it was much like any other. The very next day, Friday, a fellow got off the bus from Nashville, proceeded

to a downtown corner and began to whistle. "God has given me this peculiar ministry," he explained between tunes and repeated calls. "Help me, mighty God." The whistles sounded like bird calls. He spent the night at a downtown hotel, then caught the bus to a gospel convention in Raleigh.

THE IMAGE

Durham is kind of touchy about its image.

Image, after all, is a big deal these days. It affects a community's "brand." Durham's brand, as of 2006, is "Where Great Things Happen." But those who concern themselves with such things get frustrated because outsiders continually bad-mouth the place. They say it's crime-ridden, that the schools stink, that the inmates are running the asylum. "Not true! Not true!" declare those who concern themselves with such things, producing statistics that prove the town is not that bad at all, as towns go.

This image thing is taken seriously and has been for some time. In 1996, the county commissioners went on retreat to talk about the budget but instead spent most of their time talking about the image problem: in particular, Durham's lack of self-esteem. Some blamed internal critics; some blamed outside agitators; some blamed the media. They made a list of good things.

Candidates in that fall's elections promised to make the image better, but the problem evidently resisted all efforts because people were talking about it through the rest of the decade and into the twenty-first century. An enterprising merchant introduced "Durham Love Yourself" T-shirts. The Convention and Visitors Bureau created a volunteer Image Watch team to look out for misrepresentations and slurs.

Nor is Durham's perceived image problem a product of today's marketing and consumer culture. It has deep roots. Around 1890, the good Baptists of North Carolina were seeking a place to locate an academy for young ladies. Many communities made generous overtures to attract the school, including Durham. But when the Baptists chose Raleigh for what would become Meredith College, the burghers of Durham felt sure their town had been spurned as a disease-ridden, rum-soaked den of iniquity unfit for the elevation of Christian womanhood. Even the local press remarked, upon the settling in town of a young matron of distinguished pedigree, that she might have had a brilliant social career had she gone anywhere but Durham.

Whether or not Durham is victim of a vast disparaging conspiracy, the truth is that Durham's reputation literally preceded it. Long before there was a town, upstanding, industrious folk set roots in fertile ground: to the north,

"The Cool Continues" banner advertises the West Village apartments, reflecting the twenty-first-century effort to bestow Durham's inner city with an image of hipness. *Courtesy of the author.*

near the bottomlands of the Flat, Little and Eno Rivers that fed into the Neuse River; and to the southwest, near New Hope Creek and its tributaries, which fed into the Cape Fear. The dusty ridge that crosses the middle of the present county and separates the watersheds was good for little except a rude wagon road between Hillsborough, twelve miles west, and Raleigh, the state capital twenty-five miles southeast.

According to oral histories collected from local elders around 1906, the ground that would be Durham was known as a "roaring old place," populated by drifters and dregs from respectable settlements who catered to the needs and whims of the teamsters driving freight wagons on the road. Inns and taverns along the way gained reputations for gambling, cockfighting, hard drinking, loose women, thievery and even murder. Besides the wagoners, that business district of the early 1800s attracted students from the university at Chapel Hill, nine miles southwest, who wanted to have their fun out of sight of their faculty's prying eyes.

The roaring carried on even after Durham became a name on a map in 1853, with establishment of the Durham's Station post office, as the railroad arrived in 1855 and as a village developed into an incorporated town of around two hundred souls by 1869. Durham grew and prospered with the post-bellum success of its tobacco manufacturers and merchants, but still its saloons outnumbered its churches, and when one clergyman had the gall to preach prohibition, the saloonkeepers got his landlord to raise the rent so high that the minister had to leave town to find a place to live. Pigsties lined

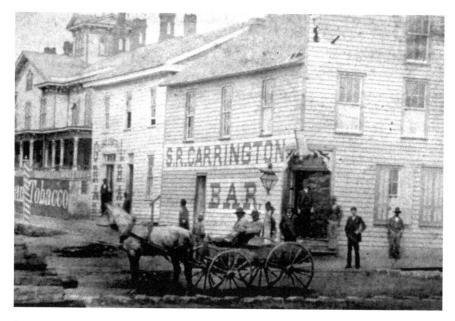

The "roaring old place" endures: Durham street scene, circa 1880. *Courtesy Durham Public Library.*

what passed for streets, the local press (the *Tobacco Plant*) chided gentlemen for spitting tobacco in church and disease proliferated from contaminated ponds and shallow wells.

Colonial Hillsborough, the feeling went, looked down on the upstart tobacco town. Elevated Chapel Hill found it uncouth. Establishmentarian Raleigh had the assumed dignity of state government, negating the inconvenient truth that the capital started out as Isaac Hunter's Tavern.

Image, though, is what you make of it, and a perceived insult once was turned to Durham's favor. The Baptists may have snubbed the town, but about that same time the Methodists were looking for an urban setting to relocate their struggling Trinity College from the wilds of rural Randolph County—about eighty miles west as the railroad ran. Durham industrial barons Julian Shakespeare Carr and Washington Duke, good Methodists both, put together a package of cash and real estate that won the school, notwithstanding that the basis of both benefactors' fortunes, cigarettes, was regarded by most North Carolina Methodists as the devil's own debauchery.

Later, in 1924, Trinity College became Duke University under the considerable patronage of Washington Duke's youngest boy, Buck. Today, Duke University is Durham's biggest employer, with about thirty thousand

on its payroll, and has brought the city a cosmopolitan degree, although some undergraduates yet subscribe to the campus folklore that Durham is the "Armpit of the South." Townsfolk, in turn, say "Dukies" are snotty, pampered and given to obnoxious partying. Turnabout's fair play, the saying goes, but we have an image problem here.

PART II

ORIGINS

The earliest documentary record of the region that would be Durham is from 1670, when an explorer named John Lederer, commissioned by the royal governor of Virginia, made an expedition into the wild country beyond the reach of settlement. He reported thick forests where resided "all sorts of beasts of prey," as well as natives who made their cultivated lands "pleasant and fruitful." Thirty-one years later, another European, John Lawson, commissioned by the governor of South Carolina, passed through, finding "rich soyl" and large flocks of turkeys. The extent of foreign incursion to the region is little known, though Virginia governor Alexander Spotswood described the Carolina backwoods in 1714 as a wretched region to which "loose and disorderly people do daily flock," and gentleman William Byrd, a member of the party sent to survey the boundary line between Virginia and North Carolina, found the Carolinians as wretched, shiftless and heathen as "the Hottentots of the Cape of Good Hope."

By the mid-1700s, though, English law and English clergy were bringing in some measure of English civilization.

The Merchant

Those who know the location of William Johnston's grave take care to keep it hidden. If a historical fellow traveler can be trusted with the knowledge, they'll show the way and—always after some careful inspecting of the ground, because it really is hard to spot—clear the leaf litter left as camouflage, and naturally deposited since the last visit, and let the old stone have a moment in the light. But before going on, it's covered over again. Just a precaution, you know.

Not that potential vandals would be too likely to stumble upon William Johnston's resting place. It's on the slope of a forested knoll, between a stream and a long-abandoned farmyard, down the remainder ruts of an almost-forgotten trail, through an unused pasture where the grass grows high, off a lightly traveled road through yet-undeveloped country. Make that country that once was developed, in the manner of the time, but has passed back to nature's keeping until there's call for changing it again.

> *To the memory of WILLIAM JOHNSTON*
> *AND ANN HIS WIFE*
> *A Worthy pair*
> *This Monument is Erected*
> *BY*
> *WALTER and AMELIA ALVES*
> *She died in 1769 Aged 42 Years*
> *He died May the 3d 1785*
> *Aged 48 Years*
> *Here also lie Interred*
> *Five of their Children*
> *Who all died very Young*

For children to die "very Young," and their parents in what we now think of as middle age, was common in what was called the Carolinas' "Back Country" two and a half centuries ago. Most people lived in isolation and passed on to anonymity, their remains gone back to earth and long since covered by grass or woods, if not asphalt or concrete. Indeed, beyond Lederer's account from 1670 and Lawson's from 1701, there is little to document those who lived beyond the Tidewater and coastal plain from the time of English arrival at Jamestown in 1607 until the incursion of English authority into what is now central North Carolina around the 1750s.

William Johnston appeared not long after the establishment of Anglican civilization, which took first form as Orange County, a section of wilderness drawn off in 1752 from three earlier-created counties; St. Matthew's parish of the Church of England, to go with the county; and a town to go with the Orange Courthouse, called first Corbinton and later, permanently, Hillsborough. There, Johnston arrived from the shire of Annandale, in the Scottish Lowlands, in 1767—following his great-uncle Gabriel Johnston, North Carolina's royal governor from 1734 until 1752. Having acquired a tract of land in Orange County, the younger Johnston settled in the county seat and opened a store across from the courthouse. Later that year, he opened a second store, handling

general merchandise as well as a goodly stock of books, on his Snow Hill plantation on the Little River in what is now northern Durham County.

His enterprises did well, and Johnston became prominent and well connected in the colony. He hired a young merchant, Richard Bennehan, to move down from Petersburg, Virginia, and manage the plantation store, which stood beside an ancient trade route between the James River in Virginia and the Savannah River at present Augusta, Georgia. Nearby, another old trail cut off and struck south-southwest, traversing present western Durham and Chapel Hill. A cobblestone section of the "University Road" remains in a forest owned by Duke University.

Johnston represented Orange County in the Hillsborough provincial congress and was a Hillsborough town commissioner. He helped start several schools in the backcountry. During the Revolutionary War, he manufactured weapons for the Patriot cause. He was also a visionary. In 1774, he and several other businessmen of Orange County formed a company to procure western land from the Cherokee and open it to enterprise—having been advised by the explorer Daniel Boone that the time was ripe and the Indians in a mood to deal. Early in 1775, the partners reorganized as the Transylvania Company, bought land between the Ohio and Cumberland Rivers from the Cherokee for £10,000 and such trade goods as the Cherokee women approved—or so the story holds—and hired Boone to lead the first party of settlers. A monument in the shape of a spear point in downtown Hillsborough marks the spot from which they were supposed to have set out.

Only one of William and Ann's children survived to adulthood. That was Amelia, who married one of her father's business associates, Walter Alves. In 1800, they followed her father's pioneers, moving to land in Kentucky that Amelia had inherited. Before they left, they had the elaborate marker carved and placed on the Johnston graves at Snow Hill. In time, Johnston's plantation was acquired by the expansive heirs of Richard Bennehan, the young man Johnston hired down from Virginia. Bennehan's daughter married into the prominent Hillsborough Camerons, who made the Bennehan-Cameron properties into North Carolina's largest antebellum plantation, covering thirty thousand acres and employing nine hundred slaves.

Time and tradition left William Johnston to lie quietly and slip largely out of mind; his tombstone has held up well, though, under its repeated blankets of leaves and within its sheltering woods beside the now-bypassed Trading Path. Someday, maybe, the old plantation will grow houses, the old trail will become a greenway and the Johnstons' resting place will become a point of historic interest—marked, tended and dutifully protected with a wall or fence. For now, a cover of leaves does the job just fine.

THE HISTORIAN

Our town became a name on the map as Durham's Station when the North Carolina Railroad surveyed its route in 1850. It became a post office in 1853, a refueling stop for locomotives in 1855, the site of the Civil War's biggest surrender in 1865 and an incorporated town in 1869. By then, it had a population of 250. Ten years later, it had a population of 2,000. By 1883, one of its leading citizens figured it was time the town had a history.

That year, Julian Shakespeare Carr, partner in the W.T. Blackwell tobacco company, whose signature brand of smoking tobacco, Bull Durham, was internationally popular (endorsed by none less than Lord Tennyson, thanks to Carr's advertising acumen), engaged a young fellow named Hiram V. Paul to research and write *History of the Town of Durham, N.C.* In later years, a scholarly paper on "Early Labor Organization in North Carolina" would describe Paul as "that versatile gentleman."

Born in 1848, Paul was intended for the ministry by his Baptist preacher father. Following his own bliss, however, the boy apprenticed himself to a printer while writing poetry and studying theology on the side. He published a book of poems in 1869 and, two years later, moved from New Bern, in eastern North Carolina, to New York, where he founded a temperance periodical called the *Evolutionist*. After six years in the North, he returned to the state of his birth to be editor of the *North Carolina Prohibitionist* and the *Raleigh Evening Post*.

In those days, newspapers such as the *Evening Post* were unabashedly partisan. Paul's paper was Democrat. One of its favorite Democrats was Carr, whom the paper endorsed in an unsuccessful run for lieutenant governor. Carr was pleased, though. He was, no doubt, further pleased that Paul wrote an article for the *Journal of United Labor* in which he charged that in the factory of W. Duke, Sons & Company—Bull Durham's main competitor—whips were "freely used on the backs of helpless little children." The Dukes, by the way, were known Republicans. True or not, Paul's claim embarrassed the Dukes enough that the driving Duke behind the tobacco enterprise, James Buchanan, paid a personal call on the Knights of Labor at its Philadelphia home office and promised to abandon corporal attitude adjustment as long as the Knights stayed out of his factory.

The Dukes, however, were not ones to let grudges get in the way of business, and they took out a full-page advertisement in Paul's book about Durham. Evidently it was Carr, though, who greased Paul's way into our town's inner circles of commerce, for in *History of the Town of Durham, Embracing Biographical Sketches and Engravings of Leading Business Men and a*

HISTORY

OF THE

TOWN OF DURHAM, N. C.,

EMBRACING

BIOGRAPHICAL SKETCHES AND ENGRAVINGS

OF

Leading Business Men,

AND A CAREFULLY COMPILED

BUSINESS DIRECTORY OF DURHAM,

TO WHICH IS ANNEXED A COMPILATION OF USEFUL INFORMATION
IN RELATION TO

THE CULTIVATION, CURING AND MANUFACTURE OF TOBACCO

IN NORTH CAROLINA AND VIRGINIA.

By HIRAM V. PAUL.

RALEIGH:

EDWARDS, BROUGHTON & CO., STEAM PRINTERS AND BINDERS.

1884.

Title page from Hiram Paul's 1884 book on Durham.

Carefully Compiled Business Directory of Durham, to which is annexed a compilation of useful information in relation to The Cultivation, Curing and Manufacturing of Tobacco in North Carolina and Virginia, Paul described Carr's partner, W.T. Blackwell, as the "Father of Durham" and wrote that to Blackwell and Carr, the town "owes much of its importance." Paul even opened his book with the story of Bull Durham's origin in post-bellum reconciliation at the farm of "Old Man" James Bennett.

Among the "Leading Business Men," Paul did his duty by patriarch Washington Duke, but Carr got a lot more ink. Still, Carr's favor must have had its breaking point. Paul settled down in Durham and tried to publish a labor newspaper, *Durham Workman*. After it failed, he tried again with *Paul's Weekly Epistle*. It failed, too. He opened the Paola Café, became a store clerk, ran up debts and went broke. Things got so bad for him that, in 1899, he asked Washington Duke for a loan to put his daughter through music school. One may only imagine ol' Wash's response, but Paul didn't get the money. Paul died April 24, 1903, having told Duke he would leave him with "his conscience and his God." Even so, Wash Duke got the better of his critic—outliving him by a little more than two years.

THE DOCTOR

Our town just sort of happened. There was a sleepy crossroads in the early 1800s, known as North Carolina's "Rip Van Winkle Era," where the east–west road between Hillsborough and Raleigh crossed the north–south road between Roxboro and Fayetteville but, as we have previously indicated, crossed little else beside the grogshops (the "roaring old places"). The infertile ridge, however, was just the foundation that the railroad's surveyors wanted when they came through scouting a route from the eastern rail junction at Goldsboro, through the state capital, then west through Hillsborough and Haw River (where a member of the railroad's board had just opened a cotton mill), to Greensboro and then southwest to the prosperous market towns of Salisbury and Charlotte. The train would give the subsistence farmers of the state's interior a link with the outside world and encourage them not only to grow cash crops but to ship them out through North Carolina ports at Morehead City and Wilmington rather than bleeding the state's capital out via the long-established trade routes through South Carolina and Virginia.

Locomotives in those days needed frequent refueling, and the railroad needed a stop halfway between a settlement called Morrisville, west of

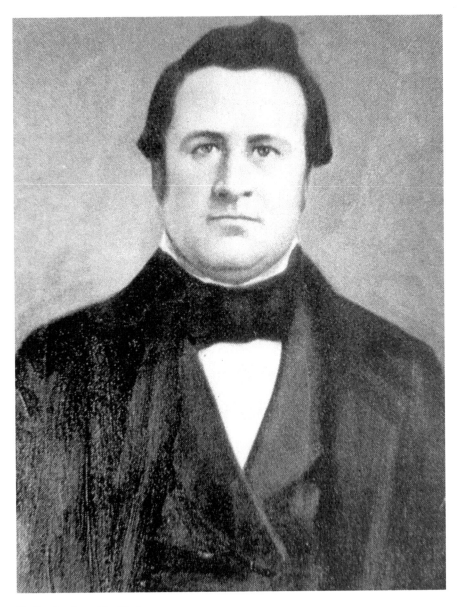

Dr. Bartlett Leonidas Durham.

Raleigh, and Hillsborough. The crossroads area on the roaring old ridge was just about right, and a young physician named Bartlett Leonidas Durham owned some land from which he would spare four acres for depot facilities and right of way. Hence, Durham's Station.

Dr. Durham came from the country, twelve miles west of Chapel Hill. Born November 3, 1824, to William L. and Mary Snipes Durham, Bartlett was a fourth generation of Orange County Durhams. Local lore says he studied medicine under Dr. James Webb of Hillsborough and then at the University of Pennsylvania, though there is no record of his enrollment in that institution. In any case, in 1847 or 1848 he bought about one hundred acres of land in the vicinity of the present Durham Bulls Athletic Park and American Tobacco complex and hung out his shingle there—figuring, perhaps, that a location along the rough and rowdy wagon road would be rewarding for a man of medicine.

Details of Dr. Durham's life are sketchy. Perhaps the best account comes from a patient, T.J. Redmond, who as a small boy came down with a case of typhoid fever. The good doctor made a house call, left instructions and some medicine, then went away and was not seen for some time, having told young Redmond he did not expect the two would meet again. Dr. Durham cared deeply for his patients, to the point that when he thought he'd lost one, he would drown his sorrows in a week-long bender. Yet, Redmond did recover and went on to serve the Confederacy in the ill-fated Pickett's Charge at Gettysburg. ("They like to killed me," he would recall.) Back home, he became an early recruit to the Ku Klux Klan and, toward the end of his life in the 1930s, shared memories of that career, as well as what he knew of Dr. Durham:

> *Dr. Bartlett Durham was a fine, portly looking man. He was a jovial fellow. On moonshiny nights, he would get a group of boys together and serenade the town...I remember on one occasion Ed Lyon, L. Turner, Jim Redmond and Dr. Durham went out to serenade. I don't remember where we went. We had some horns, a fiddle and a banjo. We went by a barroom and got some liquor. Dr. Durham would go on a spree and when he did, he would want to get in a fight. He would fight only when necessary, as he proved on one occasion. Dr. Durham weighed about 200 pounds. He came in late one night. He knew [his landlord] Andrew Turner had a dog. On that occasion, he was in the yard and the dog came toward him, the dog not having a block on him. Dr. Durham got the dog in the collar and mastered him and sat down on him...*

Origins

Dr. Durham never got married. He knocked around with the women a great deal, and he died at a woman's house by the name of Dollarhite... Dr. Durham was a fine man and when he was sober, he was strong and courageous.

Other accounts describe Bartlett Durham as the town's first railroad agent and an early storekeeper, the medical trade probably not lucrative enough to keep a young man's body and soul together. By 1852, he was authorized to sell spirits, yet as a representative to the state legislature he helped establish a Sons of Temperance chapter. Legend has it that Durham lived in a two-story home called Pandora's Box, across the track from the depot he provided for; in later years, it would be the site of the swanky Carolina Hotel, then of the Durham Hosiery Mill. Today, it's a parking lot.

Durham passed away in 1859, and his body was taken home for interment in a plot belonging to his mother's people, the Snipes. En route, he lay in state for a night at Chapel Hill, so highly was he regarded in that section. Mebane Edwards, then an eighteen-year-old slave, attended the interment but, as he recalled decades later, was most impressed by the sight of Dr. Durham's cook: "She was dressed in green silk from her head to her feet and she sure was pretty."

And so he lay to rest for seventy-five years, while the town he left his name upon grew in fortune and in stature such that its prominent citizens decided the namesake should have an appropriate place of honor. A movement commenced to have Durham's body dug up and relocated to Maplewood Cemetery in Durham. The grave had not been marked, but old-timers remembered the location well enough; on June 27, 1933, a crowd assembled and a fitting ceremony began. Mebane Edwards was called upon to speak. S.B. Turrentine, president of Greensboro College and a native of the area, presided. Sure enough, the excavators quickly struck the iron coffin and hoisted it into view.

Dr. Durham was remarkably well preserved, if a little grayish in color. His hair was still dark, and he wore a black string tie and a shirt with two small ruffles down the front, but there was a small crack in the glass plate above his face and water had apparently seeped inside for he was immersed in fluid. Those supervising the operation drilled a hole in the casket to drain the liquid off, at the same time releasing a nauseating odor. By some accounts, the smell never got out of spectators' clothing, and when a memorial service was held at nearby Antioch Church, the coffin had to stay outside. From there, the body proceeded to Durham and lay on view for some time at the Hall-Wynne funeral home. The state of Dr. Durham's

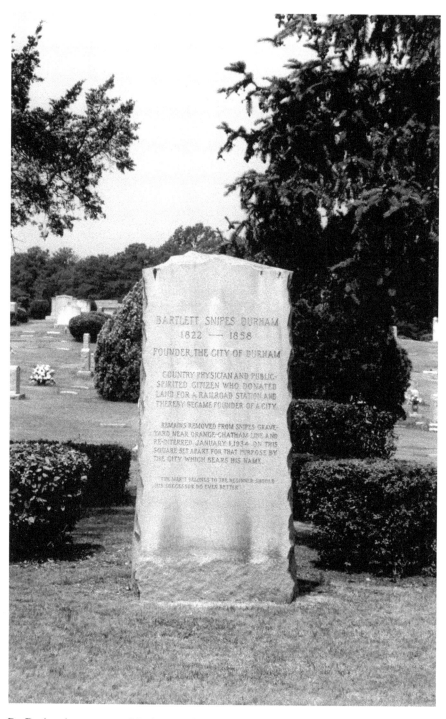

Dr. Durham's gravestone, Maplewood Cemetery. The doctor's year of birth, year of death and middle name are incorrect. *Courtesy of the author.*

preservation was so remarkable that it was reported in the *Ripley's Believe It or Not* Sunday comic strip.

Reinterment did not occur until the next winter. Dr. Durham was given a spacious plot all to himself, upon a low grassy knoll, marked with an upstanding stone that records his birth in 1822, his death in 1858 and his middle name as Snipes. All three details are incorrect, but isn't it the thought that counts?

THE POSTMASTERS

A departing school superintendent said it well, on his way to the county line: "Nothing is definite in Durham."

I mentioned the matter of Dr. Durham's own name in the story above; the spot on the map had several metamorphoses before "Durham's Station" stuck, at least in part.

So far as the good people of the Smithsonian Institution's National Postal Museum can tell (and if you can't believe the Smithsonian, whom can you believe?), it is correct that the Durham's Station branch of the United States Post Office went into service April 26, 1853. Before that, however, there was in that same country Dilliardsville, which was replaced by Herndon's, which was, in turn, supplanted by Prattsburg.

Dilliardsville may have been in the vicinity of the present-day public library, leaving its name (at least in part) on Dillard Street, later Durham's first millionaire's row, after that post office was closed in 1827 and its mail forwarded to Herndon's, which has a little more space in the historical record. William R. Herndon served as the area's postmaster from 1827 until 1836 and, in that period, dedicated an acre of his land to the east of the future town limits "for the purpose of promoting religion and education."

A two-year-old homeless congregation moved into a building there and went on to become the first organized church in Durham: Trinity Methodist. That name came only later, after the congregation was rendered once more homeless by a certain Jefferson Dillard (of unknown relation to the aforementioned "Dilliard") who, in 1835, set the church house on fire for reasons all his own but left the area for reasons that should be obvious. His destination remains unknown.

For whatever reason, Herndon gave up or was relieved of the postmaster's duties in 1836. They were passed on to one William N. Pratt, a man whose character served as counterpoint to that of his apparently pious predecessor. Pratt was an accumulator of land, and by 1836 he owned a considerable piece

of property also to the east of the future town, near present Angier Avenue and Lyon Street. Then, as now, the area was of shady reputation, thanks in no small part to Pratt, who, three years before becoming postmaster, had been indicted for maintaining "a disorderly house [for] evil disposed persons of evil name and fame and conversation to come together…drinking, tippling, playing at cards and other unlawful games, cursing, screaming, quarreling and otherwise misbehaving themselves."

At the same location, Pratt had a general store, blacksmith shop and cotton gin. The place became known as "Prattsburg," and in it the North Carolina Railroad surveyors saw the ideal spot for the refueling stop they needed. They made Pratt an offer. He countered, but set his price well over what the railroad was willing to pay. The reason, according to tradition, was that he thought locomotives going by with their chuffing, puffing, whistling and blowing sparks

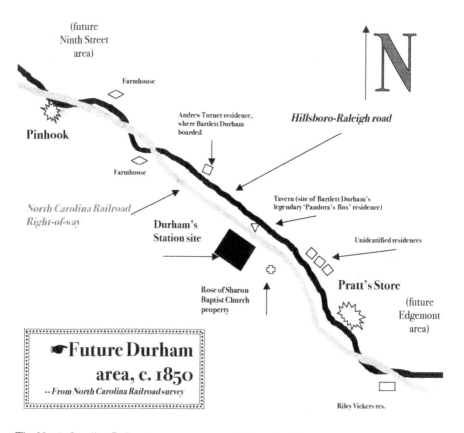

The North Carolina Railroad survey map gave the location for the future Durham's Station, as well as the notorious Pinhook and Pratt's Store.

would spook his customers' horses and drive his trade away. Whether Pratt actually thought that, and whether he had ever seen a locomotive or, indeed, ever heard of one, the bearer of tradition may form his own opinion.

In any case, the railroad said "see ya," or words to that effect, and went one landowner west, where Dr. Durham would be of different mind. Thus, the post office once again relocated and underwent a shift of identities, but not, this time, of masters. Pratt kept the job, though he had to walk a mile each way to and from his own establishments when it came time to meet the trains and sort the mail. What all went through his mind on those reflective hikes, whether he ever supposed he could have had a real town to bear his name (and, quite likely, the nickname "Prattfall"), we'll never know, but we can be sure he spotted opportunity. Even before the first train arrived, in the spring of 1855, Pratt was buying land around the depot.

As we mentioned, Pratt was an investor in land, and he owned a spread farther west along the route that would be the railroad. One holding was known as the Redmond Place, possibly in honor of Pratt's long-term paramour, Polly Redmond. The Redmond Place had a spring, and close to it a family named Peeler maintained an inn where "uproarious times were often witnessed"—as it was expressed in the Trinity Historical Society's 1906 collection of "Old Durham Traditions." Innkeeper Ben Peeler, legend holds, sometimes murdered his guests, stuffed their bodies down a well and took their horses for sale at the state capital.

Even more famed was Pinhook, on the Raleigh–Hillsborough road near present-day Ninth Street, where hipsters, those who would like to be thought hip and surviving countercultural specimens hang out; also near, in what one might say is apt symbolism, is an apartment complex for Duke University students. Pinhook (an old Southern term meaning, in essence, buying low and selling high—applied to dealings in livestock, tobacco and other commodities) was famed "as a place of rough-and-tumble fights, drinking, gambling and other forms of amusement, where the natives and visitors met to have a rough, roaring and, to them, glorious time."

With a spring and campground, as well as its tavern, Pinhook was sort of a proto–truck stop, where freight haulers stopped off and locals catered to them—such as one anonymous farmer of record who began his rise to wealth by selling watermelons to the wagon drivers who, according to "Old Durham Traditions," no doubt considered them a treat "after their long draughts of fiery corn liquor which they bought from the Pinhook grog shop." Pinhook also attracted a more cultivated clientele from as far as ten miles off: "The students of the University of North Carolina had the habit of coming over when they wished to go off on a lark."

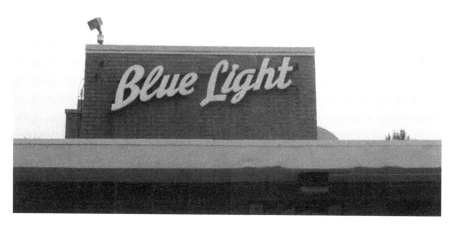

The Blue Light drive-in, near the site of the notorious nineteenth-century Pinhook, had a rowdy reputation of its own as a twentieth-century teen hangout. The sign remains, but the place is now a convenience store. *Courtesy of the author.*

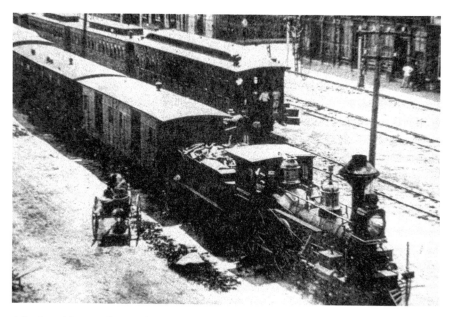

A fire-breathing, smoke-snorting locomotive in the North Carolina Railroad yard, Goldsboro. *Courtesy NC Division of Archives and History.*

Perhaps some of those young scholars also came in hopes of catching their first sight of a fire-breathing, smoke-snorting railroad engine in the flesh (or iron, as the case may have been). Had they got the idea when the surveyors came through in 1850, they could have graduated and gone by the time a train arrived, and even then, local legend has it, it came in late.

Anticipating the first train's arrival, the story goes, a large crowd gathered at the station to see the show. When it didn't show, the natives got restless. A character called Wash, "notorious rowdy, a man who drank and was known far and wide for his boisterous carousing," decided to pass the time with a nip. He rode his mule to a nearby supplier, possibly William Pratt, and purchased a jug. While he rode back to the station, though, the train approached, the mule bucked, Wash went flying and his jug was smashed. Wash's wife cried praise to glory: "Wash is safe and his jug is busted."

As we say, nothing is definite in our town. But a tradition was set. In our town, trains and timing don't mix. When Confederate president Jefferson Davis's funeral train pulled through in 1893, it was late, disrupting plans for an appropriate ceremony. In 1996, another crowd gathered, including the usual dignitaries, to see in the first train to a new passenger depot. By the time the train pulled in, most everyone had gone back to work.

But it's downright uncanny how trains have become part of the local culture.

In the 1950s, it was common for concerts in the Nelson Music Room, just 150 yards or so from the track, to have their music drowned by diesel horns. In the 1980s, culturati staged the opera *Carmen* in a courtyard between two refurbished warehouses near the track. Just as the tenor opened his mouth for the "Toreador Song"—*Whoooooo-whoooooooooooooooo! Whooooooooooooooooooooo!* The horn went on longer than the song did.

Another time, a troupe was performing *Hound of the Baskervilles.* Toward the climax, Watson is frantic because it appears that the villains will make their escape. He urges Sherlock Holmes to haste, but the unflappable detective assures him, "Don't worry, Watson. There are no trains at this hour."

You know what happened.

THE GU'MMINT

Its name established, the railroad serving as catalyst for proto-Durham to make of itself something other than—make that, as well as—a ridge of iniquity, a village accumulated in the depot district over the next few years. By the time Beauregard and the boys took their potshots at Fort Sumter,

Durham's Station—by now sometimes called simply "Durham's"—though still close-wrapped with farmland and forest, had a couple of churches, smithies, mercantile establishments, a shoemaker and its first failed real estate developer.

An entrepreneurial circuit rider, John A. McMannen, having done well as a designer and publisher of religious illustrations, invested those earnings to do even better in smut. Smut, in this case, was a wheat disease that could be most troublesome to farmers in central North Carolina, for whom wheat was one of the few cash crops. McMannen bought a patent for a gadget that separated diseased wheat from good grain, built a factory to manufacture them and prospered. About that time, the railroad came through several miles to the south of the community McMannen's own enterprise had catalyzed (South Lowell, so called in anticipation that its industrial stature would one day rival that of "North" Lowell, in Massachusetts). McMannen saw the future, took an option on land along the track and advertised building lots for sale.

There were no takers. Perhaps it was because McMannen, good Methodist that he was, put a clause into his offer that forbade dealing in spirits of the liquid kind there (presumably, dealing in spirits of the ethereal kind would have been fine). He didn't know the territory.

But Durham's Station did have the germ of industrial stature. In 1858, one Robert F. Morris set up there to manufacture smoking tobacco. "Manufacture" is perhaps too grandiose a word because what the job entailed was flailing cured and dried tobacco leaves with sticks until the leaves crumbled into tiny shreds suitable for packing into a pipe. But Morris, like others in the region, produced the stuff, using tobacco cured with the newly discovered "flue" process. Involving intense heat, the process turned out leaves of a pleasant golden color—hence the term "brightleaf"—that smoked mild and sweet. Thus was the foundation of Cigarette City laid.

The village grew, the tobacco trade thrived—a tale we'll return to in the next chapter—and, by 1867, the residents of substance decided that they constituted a town. The state legislature agreed and incorporated Durham's Station. In Washington, though, the Reconstruction Congress thought differently, and Durham's incorporation was undone when Congress ruled that any act by a legislature previously in a state of rebellion was null and void. Nothing is definite in Durham. The village elders had to go through the whole thing again, and Durham got its town status back in 1869.

Red tape cut through, the town got down to business on April 10, 1869, with a charter seventeen printed lines long and a definition of one square mile with the depot in the middle. Six aldermen, among them Robert F.

The Reverend John McMannen had an entrepreneurial soul, but his Methodist convictions got in the way of his developing a town at Durham's Station. *Courtesy M.J. Hall.*

Morris, the founding tobacco man, and a magistrate of police (a.k.a. mayor) constituted the government. When the mood struck them, they met in one another's offices or under a shade tree.

This is not to say they were not conscientious about their municipal responsibilities. Among their first actions was the establishment of ordinances against marbles and baseball on Sundays, or the selling of spirits except for medicinal uses on the day of rest. For that matter, residents couldn't sell anything else on Sunday, either, except for funeral shrouds, and gatherings that would annoy other citizens were forbidden after eleven o'clock at night.

Further, the elders set about to systematize the street system, which was, in the middle of town, a handful of dirt tracks going every which way according to the lay of land, convenience and habit. The northwest–southeast Raleigh–Hillsborough road intersected the road from Chapel Hill at an oblique angle; from that point, Mangum's Lane (later Morris Street) ran north perpendicular to the Chapel Hill road, while other lanes and paths ran perpendicular to the Raleigh road, establishing a pattern of strange angles, odd blocks and deceptive directions with names that were, at best, informal.

After defining the Raleigh–Hillsborough road's exact right of way one Sunday afternoon, by having a mule team plow furrows on either side, the

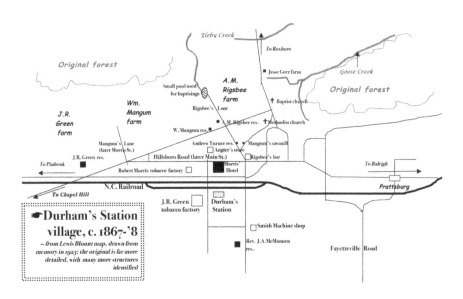

A simplified version of the map of the village of Durham's Station, circa 1865, drawn from memory by Lewis Blount in 1923.

aldermen declared that thoroughfare to be Main Street. Some locals who turned out to watch said it was all a bunch of foolishness, but the founders persevered. The lane known as Dog Trot became Pettigrew Street; Shake Rag became McMannen Street and, later, South Mangum; and Dillard Street, which the town's first rich folks lined with their mansions, was originally called Henpeck Row.

After a few more years, the aldermen were faced with another situation: what to do with the dead bodies that accumulated around town. The churchyards were already filling up, for, though the town boasted only about three hundred inhabitants, vagrants and drifters still frequented the storied ridgeline and from time to time, perhaps after lingering a little too long at a den of iniquity, left their earthly remains for the public's discretion. In 1872, the town bought a parcel of land southwest of its limits from a Mr. Willard, paying him $1,500, to use for a public cemetery.

There was, of course, objection. Louis Austin, the story goes, was a Yankee who wandered south after the war and stopped in then-growing Durham to work as a roofer. Having learned the game elsewhere, perhaps in soldiers' camps during the recent unpleasantness, Austin thought that the cemetery was a waste of money and what the town really needed was a field for baseball, and he made his feelings known to Mayor W.J.H. Durham. The mayor and aldermen heard him out and did what they wanted anyway.

Although Austin was from the North, by this time he was sufficiently acclimated to local sentiments to be a Democrat. In those times, still close upon the war and Reconstruction, party politics was a matter of strong emotions, and so, when Democrat W.N. Patterson beat Republican Washington Duke for a seat in the state legislature, it was cause for raucous celebration. Austin, along with some other young bloods, did their bit by securing an antique cannon. While more sober citizens filled the air with mere confetti, those boys fired up and fired off the cannon. It was so much fun that they did it again. And again. And again.

The cannon was old. The barrel got hot. The cannon blew up, much to the amusement of some onlooking Republicans but not to that of Louis Austin, who was left with no clothes to hide his black-powdered and armless body. Any embarrassment he might have felt was soon relieved by his death. He was suitably laid to rest, becoming the town cemetery's first resident. His gravestone came to mark one corner of a potter's field—the section reserved for paupers and the unclaimed—and, in time, Austin's identity was worn away by the elements.

More than a century later, the local Preservation Society redeemed Austin's place in Durham's history and etched it in stone—a three-hundred-pound

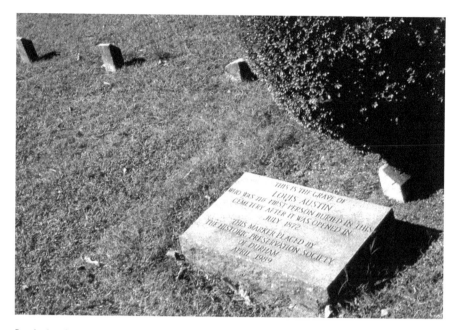

Louis Austin, who wanted a ballpark, instead became Maplewood Cemetery's first resident thanks to an exploding cannon in 1872.

hunk of rock, to be precise, donated by society members John and Kathleen Bost. Cut, shined and set in place in 1989, the stone declares: "This is the grave of Louis Austin, who was the first person buried in this cemetery after it was opened in July 1872."

Fate would deal kindly one other way with Austin. Just a few years later, townsfolk laid out a baseball diamond on a lot right across the road. Louis's ghost would have had a fine view.

THE FACTORY

It wasn't very long after Durham got up and running that it got a regular landmark. What buildings there were around town were wood, and those that served the growing tobacco trade were for the most part little more than shanties tossed up in haste by owners anxious to start cashing in on the golden leaf. By 1874, though, the little enterprise begun by Robert Morris had grown through several owners and trademark lawsuits and adopted as its emblem a bull—which came in time to represent the town itself. Business was so good that the W.T. Blackwell Company—as the firm was by then

named—felt worthy to build in solid brick. Its new factory went up, four stories high, on the south side of the railroad and beside the station. At the time, it was the biggest tobacco facility in the world, and the factory's lower floors still stand, lately remodeled into high-priced apartments.

It must have been quite a sight. Like Egypt's pyramids rising from the vast and vacant desert, so rose the Bull building from a nondescript hamlet where menfolk spat tobacco juice in church and the main form of entertainment was pickup fistfights. Indeed, a correspondent only identified as "Citizen" wrote to the local press—the *Tobacco Plant*—and railed about the image problem.

With "daring effrontery," wrote Citizen, some persons of no doubt evil intent had cast "false charges and foul aspersions…a stain upon the fair escutcheon of our bright and prosperous little village." It was true, Citizen admitted, that once Durham was "the territory where the Devil and Billy Pratt…reigned supreme," and upstanding citizens were yet "surrounded with many evil 'influences,' such as 'Bar Rooms,' 'Smoking Tobacco' &c."

What Durham had and its critics needed, Citizen held, was positive thinking:

> *If your correspondents will quit their misrepresentations…we will soon have good churches, good schools and good streets—when, save under the pernicious influence of "King Alcohol" or bewildering mazes of "Railroad Mills"* [a brand of snuff], *one might travel without the assistance of Mayor or Town Constable.*

It was in just that spirit that the Blackwell Company raised its plant, topping off with what the newspaper described as "an instrument after the style of the Calliope, which imitates the bellowing of the bull." It was fitting, for business was bullish. In November 1866, the village of Durham's Station shipped out just over 4,000 pounds of processed tobacco. By November 1871, the month's total was 65,000. In one month in 1876, the Blackwell factory alone sold 183,680 pounds and figured its total for the year would be more than 2.5 million pounds.

Durham still had a ways to go. At that same time, a citizen was threatening to sue over the sorry state of streets, the air was thick with the stink of fertilizer dumped in the middle of town and the five-point intersection of Main, Chapel Hill and Morris Streets was still a mudhole where cows came to drink after a rain. Noisy spectators and mischievous boys disrupted attempts at serious theatre and, in just two days, a caretaker at the Blackwell stables had killed 321 rats.

With industry, too, came labor. With Southern agriculture in a prolonged state of postwar depression, former farm folk streamed into the growing railroad towns in search of what they called "public work." Taking a job was disgraceful for a man who had stood on his own feet (even if they were standing on land leased from somebody else), but there was much to be said for regular pay. The Bull factory paid $1.50 a day.

Yet, the 1800s were revolutionary times, and alien notions about how business owners and their hired help ought to get along crept into even so conventional and off the beaten track a place as Durham. In the summer of 1875, the town had its first strike when Blackwell hands walked out one morning after demanding higher pay. Management simply sent a delegate out of town, and he shortly returned with forty Virginians ready and willing to take the neglected positions. Fresh off the farm, Durham's proletariat had a lot to learn about supply and demand.

The Bulls

How did the sleepy whistle stop join the Industrial Revolution? In 1862, Robert F. Morris sold his tobacco business to John Ruffin Green, who had been making a blend of his own out on the family farm until his "manufactory" burned down. Taking over in town, the astute Green developed a formula for mixing and blending his smoking tobacco so as to appeal to cultivated, sophisticated tastes—in particular, those of the college boys over at the state university (for it is well known there are no tastes more self-consciously cultivated and sophisticated than those of college boys), who passed through Durham's Station on their ways between home and campus and between campus and the Confederate army. The boys took along Green's tobacco, shared it around their campfires and built a following for it.

The other side was heard from in April 1865. Robert E. Lee surrendered to Ulysses S. Grant at Appomattox Court House on the ninth, but there remained many thousands of Confederate troops in a state of hostilities (at least on paper, since deserters had been streaming out of Southern camps to get home for plowing season), and Confederate president Jefferson Davis and some of his generals had every intention of fighting on, however they could, indefinitely.

While Lee and Grant were facing each other in Virginia, Union general W.T. Sherman, of incendiary fame, had been marching through Georgia, South Carolina and North Carolina with Confederate general Joseph E. Johnston making a futile attempt to slow his progress. The week after Lee

John Ruffin Green adopted a bull emblem to set his Durham tobacco apart from the competition. *Courtesy Duke Homestead State Historic Site.*

surrendered, Sherman occupied Raleigh and set an advance line running through Durham's Station. Johnston's advance line was at Hillsborough. On Easter Sunday, April 15, Sherman and Johnston agreed to call a cease-fire and meet the next day, somewhere between their respective lines, to talk about putting an end to the war.

The generals met on the Hillsborough–Raleigh road near a small farm belonging to James and Nancy Bennitt (the spelling later changed to "Bennett") and spent eleven days negotiating and dealing with their respective superiors. In the meantime, their idled soldiers foraged about and amused themselves as best they could—by liberating John Green's stock of ready-for-market tobacco, for example. Green figured he was ruined, but after Johnston surrendered the eighty thousand men under his command (Lee's command was only twenty-eight thousand) and everybody went home, inquiries began coming in about getting more of that good Durham tobacco from former soldiers who were now willing to pay for it. There was a sudden boom, at which point the economy of Durham and that of the South in general parted ways and the town that grew acquired a character more like those in other bullish sections of the reunited Republic.

Green, facing competition in "Durham" tobacco, picked the bull emblem to set his brand apart and took in partners, including W.T. "Buck" Blackwell

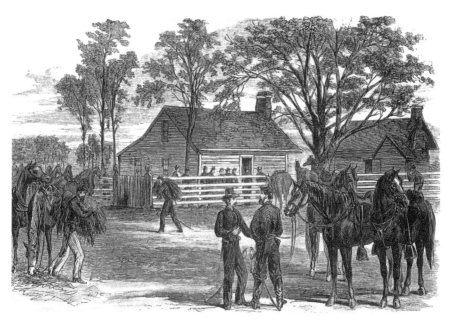

Soldiers "requisition" hay at the Bennett farm near Durham's Station, April 1865. Others similarly "requisitioned" John Green's stock of tobacco. *Courtesy Bennett Place State Historic Site.*

and J.R. Day, who bought the firm outright after Green's death in 1869. They, in turn, brought in a third partner, Julian Shakespeare Carr from Chapel Hill by way of Arkansas. That triumvirate, blessed with business savvy and Carr's flamboyant knack for marketing, turned a humble hometown enterprise into a nationwide, and even international, phenomenon as teams of sign painters painted "Blackwell," "Durham" and the bull on any vertical surface that would stand still long enough.

Hiram Paul, their hired historian, called "Col. Buck" (who actually paid a surrogate to do military duty for him) the "Father of Durham." It was mostly Blackwell's idea to open an auction house next to their tobacco works in 1871, giving nearby farmers a place to sell their crop without having to haul it to markets in Virginia and getting them higher prices by letting manufacturers bid on what they wanted. With a market handy, Blackwell and company also assured themselves of a steady supply of raw material and in the process set up the town's first industrial spinoff as one auction floor after another opened in the next few years and directed money into the stream of our town's commerce. That money supply brought in the town's first bank, opened by Julian Carr's college pal Eugene Morehead, son of the governor who got the North Carolina Railroad underway; and the town's first cotton mill, which Carr himself opened in 1884.

It was Colonel Buck who kept the first public school in town going, putting up his own money when political opposition cut off the school's tax appropriation. He cashed out of his namesake tobacco company in 1883, and went into banking and real estate. Blackwell came to own a horse-racing track just outside town, Blackwell Park, site of a future Duke University campus, and estimated that he had three hundred houses to his name, as well as a personal wealth of more than $1 million, by the time his soul was saved by a brimstone-breathing evangelist named Sam Jones during an 1888 revival. Blackwell would need all the spiritual sustenance he could get—just a few weeks later, Blackwell's Bank of Durham failed and took sixteen Durham businesses down with it. The Father of Durham spent the rest of his life paying debts and feeling sorry for himself, living largely on charity from his former competitors in tobacco, the Duke family, until he died of a stroke in 1903. In death, his stature was redeemed. The town's aldermen, Masons, Odd Fellows and Knights Templar marched in his procession. along with two companies of militia. A eulogy affirmed what Hiram Paul had written: "To say that Col. Blackwell was the father of Durham, would be putting it mildly."

Blackwell's partner, Carr, was another case entirely. If Blackwell was an honorary colonel, Carr was a self-made general—so says the inscription on

W.T. Blackwell took over the tobacco company after John Green's death and became recognized as the "Father of Durham." *Courtesy Duke Homestead State Historic Site.*

his tombstone in Maplewood Cemetery. In his portrait at the public library, he is depicted in the uniform of a three-star Confederate general, when in fact he mustered out at Appomattox as a one-stripe Confederate private. Wealth and fame account for much, though, and by the time the history of Carr's old regiment was published in 1899, he had enough of both that his service photo (as a lad whose chubby face might have yet needed a razor) appears on the frontispiece, along with the weathered and bewhiskered visages of five genuine officers.

Carr's father, John, had been a partner with Bartlett Durham in a store at Durham's Station and did well for himself as a merchant in his own town of Chapel Hill. His boy Julian grew up there, spent a couple of terms at the university and then dropped out for the adventure and glory of wearing a uniform while he rode his horse fast. Displeased by what he found at home after the war, Carr went west and took a job in a relative's store in Arkansas. Perhaps his father felt that proximity to the frontier, with its buffalo skinners, gunslingers and wanton women, was no place for a hot-blooded youngster. Maybe he just saw a good investment. In any case, when Blackwell and Day were shopping for capital, the elder Carr bought a third interest in the Bull firm and lured Julian home with it.

Flamboyance aside, Carr had a fine head for business and ambition to match. Making a fortune in tobacco, he branched into textiles, banking, streetcars, railroads, electrical power and farming, as well as the affairs of Confederate veterans—another route to that honorary generalship. He set his hands to politics, religion, higher education and even international affairs—the latter, perhaps, in a way he didn't realize.

"Let buffalo gore buffalo," went Julian Shakespeare Carr's pet motto, "and the pasture to the strongest." Yet he had his weaknesses, vanity being one. As a banker, Carr took particular notice of loans coming due, personally deciding which might be renewed and which he wanted paid, in full, right now. According to one of Carr's clerks, Southgate Jones Sr., a traveling ammunition salesman named George Lyon was directed to pay up, and he showed up, as directed, on the appointed day at the bank. Putting on his best salesman's smile and straightening his coat, Lyon charged into Carr's office with his hand thrust out and a "General, I certainly am glad to see you! I don't believe I've had the pleasure of shaking your hand in six months... That necktie! It's the most gorgeous tie I've ever seen...I've been over the greater part of the United States in the past two months and haven't seen a tie that could compare with it."

Etc., etc., etc. Lyon got his loan renewed.

Blackwell's partner, Julian Shakespeare Carr, in costume as a Confederate general. *Courtesy George Pyne.*

FORTY-FIRST REGIMENT.

1. A. M. Waddell, Lieut.-Colonel.
2. Roger Moore, Lieut.-Colonel.
3. R. S. Tucker, Captain, Co. I.
4. J. Y. Savage, 1st Lieut., Co G.
5. Norfleet Smith, 1st Lieut., Co G.
6. Julian S. Carr, Private, Co. K.

Julian Carr, at bottom, was a mere private in the Confederate army, but his wealth and fame earned his youthful likeness a place in the military record. *From Walter Clark's* Histories of the Several Regiments and Battalions from North Carolina in the Great War 1861–1865.

THE COUNTY

With our town turning into the little economic engine that could, the chains that connected it to colonial Hillsborough started to chafe through the generally desolate 1870s.

Durham was the place in old Orange County where business was done, products produced and money made, but Hillsborough remained the seat of government. That meant that to register a deed, file a lawsuit or petition the commissioners required a trip of fourteen miles each way—that is, a full day shot to get there, do business and get home for supper, having to travel either by the windy, bumpy road or by the train that ran once each way each day.

From 1870 to 1880, the population in our town's one square mile had shot from 250 to more than 2,000. Eight out of every ten legal instruments processed through the Orange County courthouse pertained to transactions in Durham. Equally galling, from the point of view of Durham's bulls, ever since their town's incorporation its aldermen had been in dispute with the county powers over who had the authority to issue and collect from liquor licenses. Clearly, for the booming little municipality, this state of affairs was not acceptable, and citizens such as Blackwell, Carr and E.J. Parrish— auctioneer at the town's first tobacco sale and by now owner of a block-long warehouse of his own—began plotting to carve off a county of their own.

Caleb Green, the *Tobacco Plant* editor, was a delegate to the North Carolina General Assembly and, in early 1881, sponsored a bill to take the eastern half of Orange and odd bits of three other counties to make of them a new jurisdiction. The bill had general support from plain folk in the affected areas, all of whom would benefit from having a county seat closer to hand; it had general opposition from the established interests in the affected counties, as well as from North Carolina's historic antipathy to change. Compromises at the capitol removed two counties' territory from the proposition and aligned Durham interests with those of another proposed new county, Vance, up on the Virginia line. After several weeks' backroom dealing, the legislature authorized a public referendum, and in April the public voted (roughly six to one) to create Durham County. There was some sentiment to name the county "Mangum," after antebellum U.S. senator Willie P. Mangum, but when it was pointed out that "Durham" was a well-established brand, the wisdom of commerce prevailed, moving one traditionalist to lament the bulls' triumph:

'Tis at Durham's Bovine Nod
Our "Solons" bend the knee

In coming years when we shall see
A cow with wrinkled face,
We'll think of that unhallowed spree
That did our state disgrace.

The Brand

As we have described, the bull symbol became associated with "Durham"—as in "Durham tobacco"—through John R. Green's inspiration in 1865 or 1866. The wide success of Blackwell's brand turned association into practical synonymity, to the extent that the 1889 city directory declared that "the 'Durham Bull' is the genius of our young city." It's not so clear, though, just when and how the venerable nickname "Bull City" came into the popular lexicon.

The earliest example we have so far identified is from 1902, the same year a Durham baseball team first took the field as the Bulls. A listing appeared in the city directory that year for the Bull City Tailors and, a few years later, Bull City Drug was in business. Interestingly enough, both businesses had

Carr's flamboyant advertising made Bull Durham a hit with smokers and the bull synonymous with Durham. *Courtesy Duke Homestead State Historic Site.*

African American owners. In 1908, a Bull City Transit Company began automobile service between Durham and Chapel Hill, as long as the road was dry enough that the cars didn't get stuck in mud. That was followed, in 1912, by the Bull City Cigar Manufacturing Company. In the meantime, two Durham druggists concocted a headache remedy and put it on the market in 1910 as BC Powder—though the initials actually referred not to "Bull City" but to inventors Germaine **B**ernard and C.T. **C**ouncil.

As time has gone by, local boosters have coined other nicknames for the town: "City of Medicine," for example, and "City of Exciting Stores." Outsiders have contributed "Cigarette City," "Fat City" (*Esquire* magazine, April 1972, for a cover story on Durham's weight-loss industry) or "Chicago of the South"—the latter a term equally applicable to the town's industrial shoulders and political character. Hardly a wonder that the name that has stuck, has stuck: "Bull City" just seems to say it all.

PART III

A GOLDEN (-LEAF) AGE

For our town, the term "Gilded Age"—referring to the American period roughly from the centennial of 1876 until the entry into World War I in 1917—has a double meaning. With the town's industrial explosion and population boom from perhaps one thousand to about twenty thousand residents, accompanied by the advent of such amenities as automation, running water, electricity, automobiles and lavish places of residence, the one-time whistle stop indeed was in tune with its times as it reached the fiftieth anniversary of Durham's Station's establishment. In our town's case, too, the gild referred to the gold-colored brightleaf tobacco upon which its success was founded. It was a time of optimism, energy, expansion and very important people with very important money, but it was also a time when the engines of progress could come up against more down-to-earth concerns.

THE ICE CASE

There are recurrent themes in our town's story—motifs, if you will. We have already talked about the trains' ill sense of timing. Overtime parking is another: whether to meter or not, how zealously to ticket and how to strike a balance between enriching the city coffers and not driving business away. And then there is the administration of justice, sometimes seemingly capricious and more often like a revolving door. One time, they all came together.

It was in June 1892. It was, no doubt, warm in town when the *Durham Weekly Globe* reported that "a case full of interest was tried before Squire Angier...It seems that Jake Price, who has charge of the switch engine on the R&D, left a string of freight cars near the Market House."

"Squire" was Malbourne Angier, merchant and alderman; the "R&D" was the Richmond & Danville Railroad, which by this time had leased the original North Carolina Railroad line through Durham. It happened that citizen J.W. Hutchins, butcher, was heading home with a cake of ice when the idling train blocked his way. By the time he could proceed, he claimed, his ice had all melted away.

Now, as the *Globe* pointed out, the law in town was that, "if trains are left for a period of time longer than five full fleeting minutes, the engineer who leaves the cars there shall be yanked up and be made [to] cough into the general fund of the municipality the sum of ten dollars and trimmings."

Having lost his ice to the trainman's delay, an indignant "Col. Hutchins" alerted the constabulary and had engineer Price arrested. When the matter came to trial, a "Major" Guthrie represented the railroad and "Colonel" Junius Parker represented the affronted city, while "Squire" Angier toyed with the goddess Justice, who is barefooted, and the case commenced. Hutchins was positive that the train was on the crossing fifteen or twenty minutes, while Price swore that it was not there over five. Speeches were made, and then the court, to get down to the details of the case, asked Mr. Hutchins how large a cake of ice he had.

"I paid for ten pounds," said the Colonel.

"Do you reckon that there were ten pounds of it?" asked the court.

"I refuse to criminate myself or an ice man," responded Hutchins.

The newspaper continued:

> At this juncture, the court sent Officer Woods out with a requisition for 10 pounds of ice and a string. As we go to press, the court is holding the ice in his hand in the sunshine, trying himself to see how long it takes to melt, while Maj. Guthrie is contending that this is a cooler day, that the ice man for once in his life and never before had given too full weight, that the string is of a different variety, and that the whole rip-roaring, ram-jamming business is irrelevant, incompetent and immaterial.

You may have always wondered where television's Hamilton Burger got his immortal objection to his eternal courtroom nemesis, Perry Mason. Now you may have an idea. Sorry to say, the case's final outcome went unrecorded by the *Globe* or any other local agency of the fourth estate. Perhaps the railroad just paid up and shut up. Perhaps it held its ground, as it was wont to do; perhaps, in some great Durham in the sky, some unfortunate bailiff is still standing in the sun, by the track, waiting to see how long it takes ten pounds of ice to melt. Such is the majesty of the law.

THE ROMANCE

Edgemont was a tough neighborhood, but it was there one Thanksgiving that true love did prevail.

It happened in 1902, and it happened to Ed Barton and Mattie Teasley, who, as the local press put it, "ran against a rock they did not look for."

How Ed and Mattie came to know each other and discover they were kindred spirits, we do not know. Edgemont was a cotton mill village just outside the Durham town limits, beneath the Millionaire's Row along Dillard Street in a lowland formerly called "Smoky Hollow" and known as a red-light district. Upstanding citizens were glad when tobacco, textile and banking tycoon Julian Shakespeare Carr, that upstanding citizen, decided to put up a factory and housing for his hands down there, figuring that honest industry would remove the smirch upon Durham's good image. It was Carr, who could overlook the hollow from the backyard of his mansion, who bestowed the name "Edgemont," which sounded highfalutin, and gave flower names to soften the image of the neighborhood's streets.

So Edgemont was not a large place, with the mill its single focal point, and it would have been only natural for Ed and Mattie to encounter one another in the course of regular affairs. And so, on the Monday before Thanksgiving, November 24, they secured a license to wed and engaged J.E. Owens, justice of the peace, to do their honors that evening at the bride's home at Main and Elm Streets, next to the new Baptist church.

When Owens arrived, however, he found the home prepared not for celebration but as if to withstand a siege. Mattie, in her bridal best, was confined in her room, while half a dozen of her father's acquaintances were patrolling the yard with firearms. The good justice figured his services would not be required that night, the prospective bridegroom having been sent packing and his chances of securing his intended for an elopement not looking very good. Indeed, Ed had got the message, for the next morning, bright and early, he returned the license to the register of deeds, admitting it had been issued under false pretenses.

What had happened was, when Ed and Mattie came in the day before, they had no proof they were of age. Told to go home and come back with notes from their parents, they left, forged the notes and returned to get the license. So, Ed said, there wasn't going to be any wedding at all, a sentiment that Papa Teasley separately affirmed later in the day. However, that very night, Ed Barton's brother Will appeared before Justice Owens with his fiancée, Addie Lloyd, who had slipped out a window without her parents' knowledge so as to be present.

Wednesday morning, all seemed back to normal. Teasley's guards had gone home and put away their shotguns, and Mattie left the house as usual to go to work. It was not until she failed to return that afternoon that her elders realized they had been had.

Ed's returning the license had, just as he intended, convinced the Teasleys that he was giving up his suit. However, he and Mattie had made secret arrangements and, as soon as she was out of view of home, she changed her course for a meeting point. Together again, the lovers made for the county line. Word reached Durham that afternoon that they were indeed husband and wife. Mr. Teasley told the newspaper he knew about the trick all along but had changed his mind since the young folks were so determined to have things their way. Whether he was just trying to save face, we do not know; nor is it written what he had against young Barton in the first place.

Nor do we know where the Teasleys spent the next day, but we may assume that Ed and Mattie, wherever they were, gave thanks.

THE POLITICIANS

The golden-leaf period had its episodes of sweet justice, but it could also be downright ugly, even in Durham. As we've noted above, party politics was stuff to stir the blood, fire the will and even get downright personal at times. For example, there was the aftermath of the 1888 general election, when Republican Benjamin Harrison unseated incumbent Democratic president Grover Cleveland in the Electoral College, even though Cleveland won a majority of the popular vote. So much for the nation. Down home there were charges and countercharges of local mischief, too, as the *Durham Recorder* of November 14—eight days after the balloting—made clear:

> *Bulldozing Eaves of the Republican State Executive Committee, in one of his intimidating secret circulars said that he would see that illegal registering would be punished and made great threats… Will he do it? Will he investigate the 2d ward of Raleigh where more votes were polled than were registered? Will he prosecute the men along the railroads who were registered in different towns and attempted to vote in two towns the same day?… Will he prosecute the convicts registered and who were made to believe they were entitled to vote?*

The 1888 elections for Durham were not mere popularity contests among Democrats, Republicans and an ill-defined gang of "Rads" (as in "radicals"). They were morality plays, crusades pitting honest Democratic

(a.k.a white) men against corrupt and wicked Republicans (a.k.a. blacks and carpetbaggers), and morality was running high, for evangelist Sam Jones had just finished a ten-day revival in town, so stirring the soul of Durham that he took in $165 from his last night's collection.

Before the election, the Democratic press asserted that Northern money had flowed into North Carolina "as a corruption fund" for buying Republican votes. Durham's "boss Rads" had gone so far as to nominate physician Aaron Moore, "colored," for the powerful post of county coroner. "White men of Durham," called the *Durham Recorder*, "those who have any respect for the Anglo-Saxon race, will you fail to do your duty on the 6th of November? Will you allow Negro rule or a white man's government?"

Although Durham's *Tobacco Plant* (by this time owned by Julian S. Carr) could trumpet "Durham County Redeemed; Democratic From One End to the Other" after the election, the actual vote left much unsettled. Apparently, the *Plant*'s editorials annoyed some of other mind, for barely had the votes been counted when the home of editor Caleb Green—who was also chairman of the county's Democratic executive committee—went up in flames.

The unfortunate homeowner reported:

> *This morning about two o'clock the fearful sound of the fire bell aroused our citizens…The fire was clearly incendiary, for when the fire companies began throwing streams of water on the building it had no effect upon the fire and showed most plainly that the end of the house had been saturated with oil, and then set on fire by some fiend.*
>
> *This infathomable, this dastardly act, was done through revenge because he had done his duty as a white citizen of our town. We firmly believe that the torch was applied by certain negroes, instigated thereto by the incendiary teachings of certain white men of our town…It makes the blood of every white man in the town boil with rage, to think that he should suffer in this way for having so manfully done his duty.*

That was in the news story. In an editorial, the *Plant* explained:

> *The negro, if he would, is not allowed to vote the Democratic ticket, for fear of serious bodily harm, if not actual death at the hands of the colored people. Not content with this, if a white man dare be active and works prominently in the interest of the Democratic party, he is liable to have his helpless wife and children turned homeless into the street at dead of night, by the burning torch. White men, in name of God, how can you do otherwise than stand by your white neighbor!*

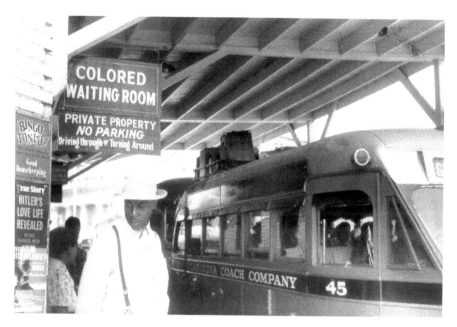

Durham bus station, 1940. Race-baiting figured prominently in local politics even before segregation became the law in the 1890s. *Courtesy Library of Congress.*

Oddly enough, just two columns over in the same edition, chairman Green's paper cautioned that, "It will be well for both parties in the present excited state of our town to be very careful of their words, and not say anything calculated to increase the bad condition of affairs."

In days to come, rumor settled responsibility upon blacksmith E.G. Jordan, a former Rad candidate for constable and alderman and, moreover, a well-known member of the Knights of Labor—an organization in whose office investigators found, after the 1886 Haymarket Riot in Chicago, a written statement that the red flag would one day fly over Durham, "Vive le commune!" Thus soundly implicated, Jordan was called upon by a lynch mob and would have met an untimely end had not E.J. Parrish, the tobacco warehouseman who had married Julian S. Carr's sister, persuaded the aroused citizens to just run Jordan out of town. The mob, so moved, bought Jordan and his family one-way train tickets, and the affair was settled without harm to life, limb or neck, but it did have an effect upon Durham's fair image in some quarters.

The *Wilmington Messenger*, a black-owned paper, tut-tutted:

> *Situated as we are in localities of large colored populations at the South,*
> *where the least feeling and excitement may at any moment precipitate riot*

and bloodshed between the hot-headed of both races, the conservators of peace have to be constantly on the alert to prevent the worst consequences.

In reply, the *Recorder* huffed: "The man or writer, white or black, or the newspapers that champion the case of the fellow Jordan and his secret modes of stirring up strife and embittering the minds of one class against another, or any other white-skinned man like him, is no true friend of peace, order, Durham or the State of North Carolina." A decade later, the *Messenger* would be silenced in the Wilmington race riot of 1898, which followed an electoral sweep that ushered in North Carolina's long Democratic hegemony and the age of Jim Crow.

In Durham, it was probably just as well that other events quickly took precedence in the community mind. Just days after Jordan's departure, W.T. Blackwell's bank went broke, sending the whole town into a depression and giving tempers a chance to sober up.

THE HOSPITAL

Democratic rhetoric aside, the aforementioned Dr. Aaron Moore, "colored," was one of a good number of African Americans who were doing quite well in the Durham of post-Reconstruction, pre–Jim Crow years. A map of Durham's Station circa 1865 (though drawn from memory decades later— see page 48) indicates two black artisans' establishments in the village—a smithy and a shoe shop—and after emancipation some of the former slaves from plantations in the county's fertile northern section pulled stakes up and came looking for employment around the railroad and tobacco works. By 1870, several owned land on the south side of the tracks, and two black congregations were in business that would go on to become the prestigious and powerful White Rock Baptist and St. Joseph's African Methodist Episcopal Churches.

Later on, enterprising black citizens would even turn segregation to an advantage, building highly profitable businesses that catered to African Americans who felt uncomfortable, their patronage not entirely welcome at white banks, insurers, mortuaries, contractors and the like. By the 1920s, our town would be described as "capital of the black middle class" by the sociologist E. Franklin Frazier. For all that, discrimination was painful and problematic—for example, when tobacco tycoon George Washington Watts paid for a hospital in Durham but restricted its admissions to white only.

Br'er Rabbit never pulled a better one on Br'er Fox. Moore had been wanting a place where blacks could get medical services and black physicians could practice, and he, like his associates in the African American entrepreneurial class, had good connections with their white counterparts across the tracks—some by shared interests in business, some by blood, for it was (and is) commonly believed that the Duke boys, Julian Carr and other prominent white businessmen had half-black kinfolk.

Now, it just so happened that about this time (the late 1890s), as the story goes, the Duke boys Ben and Buck got the idea that they should do something to honor those slaves who, back in the war, loyally remained on the job to help the white womenfolk keep the home fires burning. A statue, perhaps. The Dukes took this proposition to some leading citizens of color. "Well, that's very thoughtful of you," the response is supposed to have been, or words to that effect. "But what we could really use is a hospital of our own."

Whatever the motivation, Ben and Buck put up $8,000, and Lincoln Hospital was built. But there was compromise on both sides. The boys put up a plaque by the front door that said:

> *With grateful appreciation and loving remembrance of the fidelity and faithfulness of the Negro slaves to the Mothers and Daughters of the Confederacy, during the Civil War, this institution was founded by one of the Fathers and Sons. B.N. Duke J.B. Duke W. Duke Not one act of disloyalty was recorded against them.*

THE GOOD TIMES

Now, you may have the impression that our town was in those times a kind of a wild and woolly, rough-and-tumble, downright crude kind of place.

And you would be correct. While there were gilded mansions on Dillard Street and greenbacks flowing into bank vaults (some of them, anyway), and while some citizens enjoyed the finer pleasures of theatre and music and found their elevation in church, not even the sublime amusement of watching trains come and go would satisfy some of ruder taste.

Consider the spectacle greeting good people one Sunday morning in 1875: "Logan Groom and John Kelley, were not only violating the holy Sabbath but were cruelly, unmercifully and cowardly beating and mangling the person of an old, inoffensive, gray haired man, and that too, in the very centre of town, Main Street."

A Golden (-Leaf) Age

As Citizen Green's newspaper described it, Kelley stood by with rock in hand while Groom administered a sound, but apparently unwarranted, thrashing of one B.F. Haight, "a man of no character, yet…inoffensive," whom Groom was accustomed to entertain himself and any who cared to look on by "tantalizing, fretting and abusing."

To be fair, most of the country round about was recreationally challenged at the time. In Yadkin County near the mountains, revenue officials were accused of "wantonly and in violation of law destroying whiskey distilleries." But uncivilized pastimes endured in Durham, even after the town got moving pictures and a library. As late as 1911, one October sunrise revealed that some merry pranksters had tied a cow between two railroad cars "for no other [purpose] than the brutal desire to do injury." Fortunately for the cow, a conductor set her free before she was ground into hamburger or butchered in plain sight and open air. Three years later, some "down town sports and loafers" had their fun with "a poor demented white woman…Some smart Alec would ask her a question and the crowd would guffaw at her reply." As if that weren't bad enough, two officers on duty nearby did nothing "to disperse the crowd or get the woman to a place of safety." The local press declared it all "A Shameful Sight."

Then there was the gallivanting truck salesman whose escapade was halted by ol' Wash Duke himself.

It was by now 1914, and Trinity College had taken its place on the old grounds of Blackwell Park, complete with a statue of benefactor Washington Duke, who sat regally facing the campus gate and Main Street, alert in case any coed of uncompromised virtue should pass, requiring him, as a gentleman, to rise. It was spring, when young men's fancies turn away from whatever good sense they have, when Williamson Menefee, a demonstrator for the White Motor Car Company, took a spin through town.

Menefee had come to Durham from his home base in Greensboro, fifty miles west, for the purpose of showing off a new truck. In the process of so doing, he picked up a load of ten or twelve young sports, including some ballplayers from Jersey City who had come down to challenge the local Bulls, and rode them out to campus for a spin around the oval drives commemorating the old racecourse.

Caught up in the excitement he was causing, Menefee and the boys from Jersey yelled and beckoned the students to hop on; in no time at all there were about fifty revelers onboard as Menefee made one more round of the campus quadrangle and accelerated back toward town, narrowly missing the school flagpole but not managing to avoid the philanthropist's rear end.

Ol' Wash was not amused. Nor was he moved. Nor did Menefee's truck move any more, for the collision had cost it an axle and both front wheels. The ballplayers and the students brushed themselves off and went back to mind their own business, and the deflated Menefee was left to—well, we really don't know what he did. Maybe he went back to Greensboro and fessed up; maybe he caught the night train east. Maybe he went to the ballgame. His fate was ignored after a more pressing matter took over Durham's attention, a fire that wiped out a million dollars' worth of downtown.

It broke out in a building owned by Brodie Duke, ol' Wash's eldest son.

Those boys, those boys, those boys.

Fortunately, not all street theatre was the product of plain meanness or abject stupidity. On another occasion, a column of water shot high from Main Street, making the shape of a fan with graceful descending curves and rainbows "that shimmered and danced up and down the liquescent column as gracefully as a beautiful girl's dainty fingers toying with the strings of a tuneful guitar. Not only did the waters delight the eye, but refreshed and baptised quite a number of the onlookers who were supervising the job." The job, that is, at which a workman was engaged when he hit a lead water main with his pick.

THE BARN

If anyone were to, in a fanciful moment, put our county and agriculture into the same thought, the agriculture would in all likelihood have to do with tobacco, *Weedus incorrectus*. Wasn't always so, though.

Tobacco started out a Virginia crop, spread up into Maryland and down into the region just below the Carolina line. Most farming farther south was of the subsistence variety; the few big landowners who could grow cash crops and somehow get them to a market seventy to one hundred miles away were mostly raising corn, wheat and cotton. It pretty much stayed that way until W.T. Blackwell started buying tobacco in our town on a regular basis, and then the railroads opened up the ideal brightleaf lands down east.

Fendal Southerland was a cotton man. His people settled on the north side of the mid-county ridge, along Ellerbe Creek, some time in the 1700s. Fendal was born on Washington's Birthday in 1800. Growing up, he went to work managing the Stagville plantation up near the Flat River and got to be best friends with his employer, Richard Bennehan—good enough friends that Bennehan's will included a sizable cash bequest for his manager. After about twenty-five years on the plantation payroll, Southerland started

A Golden (-Leaf) Age

Philip Southerland's barn in southern Durham County. Surrounded by new development, the field in the foreground has grown up to block the barn from view.

having trouble with his health and had to retire. He took several years to rest and recuperate, then took some of his bequest and bought 1,435 acres in the county's deep south.

Most of that section is too swampy for growing things, but geology had provided one distinctive touch: a long peninsula of well-drained high ground that was just the place to grow cotton. Southerland planted and prospered. He built a big home, a big barn, a gin and a big cotton press—a machine for packing ginned cotton into bales for shipment. By the time the War Between the States broke out, he was the number three cotton grower in Orange County, producing twenty bales a year when the region's typical grower was making two or three.

The Yankees came in 1865. From his front porch, Southerland might have seen muzzle flashes in the bottomland along the road between Raleigh and Chapel Hill (present-day Stagecoach Road) as Union troops and retreating Rebs skirmished the rainy night before their commanders called cease-fire. But if they bothered Southerland, he left no record of it, unlike his neighbor on the north, Stanford Leigh, whose farm was cleaned out but who managed to secure a little government compensation years later.

Scathed or not, Southerland carried on. He established and ran a co-op for cotton growers, but after he had been in the cotton trade for twenty-eight years, he couldn't summon up the stuff to face yet another downturn in the market. On January 22, 1878, he took one last walk out to his barn and hanged himself. His house and barn remain, along with a cog wheel fifteen feet across from his cotton press, but the cotton grows there no more. Condominiums are the more favored crop today.

The Visionary

Let it not be thought, however, that Gilded Age Durham was all roaring and rowdiness. People of finer sensibilities already fretted over the image thing, and it was not too long after Trinity College came to town that its faculty and some enlightened people of the town had achieved a landmark of high culture: the state's first public library, right in the heart of town at Five Points. It made such an impression that, just beyond the town limits in the West Durham cotton-mill village, pharmacist W.M. Yearby put a room above his store to similar use.

Trinity professor Edwin Mims and Lallah Ruth Carr, daughter to Julian Shakespeare, were prime movers behind the library's founding, but the institution's inspiration went farther back. The earliest vision was expressed in 1881 by tobacco executive George W. Watts, imagining a Durham twenty years in the future. By 1901, wrote Watts, the "spirit of public improvement" would have "developed to a wonderful degree." The streets would have been paved with macadam and block, and a city hall, courthouse and lyceum would stand proud in brick and sandstone, while men of worth would commute to work from homes in Chapel Hill and Hillsborough (keeping up appearances, no doubt—that image thing) via horse-drawn railways. Adjoining the lyceum, where the finest speakers and writers of North Carolina came to expand minds and elevate eyes, the library would have twenty-five thousand volumes, although receiving "a good deal of opposition at first and many predictions of its failure (and I may confess that I was among the doubting ones) but it survived all difficulties."

A vast transformation, Watts considered, from the Durham of the time he wrote, "its name might then very properly have been derived from the contraction of two words, Dur from dirty, and Ham from hamlet or village—a dirty village." In some parts, Watts's vision was not too far off. A public library, one might think, would be a point of considerable civic pride in a town once looked upon as a squalid temple of Mammon. However, when the Merchants' Association published its *City of Durham Illustrated* in 1910, the booster book devoted many glowing paragraphs to the Hawkeye Café and Carolina Soda Water Company, but for the library it could spare not a single word.

THE CHAMBER

Another civic amenity to come along in that time was the chamber of commerce. According to records of the North Carolina secretary of state, the Durham chamber was incorporated April 27, 1906. Of course, the story isn't quite that simple. There had been several earlier efforts to establish such an organization. In the 1880s, the Commonwealth Club promoted industries' interests and advertised all the town had to offer. That group died out around 1890, but within four years it was followed by a chamber of commerce, in name as well as function, which managed to elect officers at its one and only meeting before vanishing from the record.

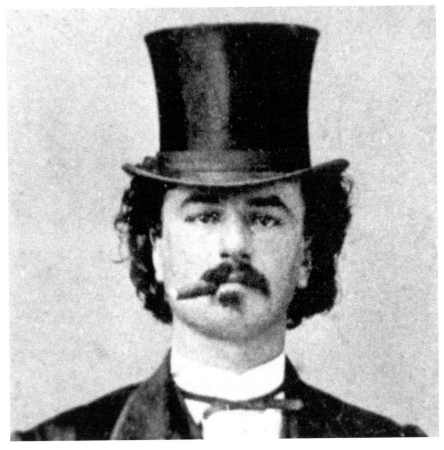

The dapper E.J. Parrish was Durham's first tobacco auctioneer and saved a labor leader accused of arson from a lynch mob in 1888. *Courtesy Duke Homestead State Historic Site.*

Organizing a second—or third—chamber of commerce began in 1902, and the 1906 articles of incorporation defined its objectives as to "promote the business interests…direct attention to [Durham's] superior advantages… induce capital to locate therein," encourage commerce and industry and welcome new enterprises and their representatives. The first president was tobacco man Edward J. Parrish.

Now, between Parrish and his brother-in-law, textile and banking tycoon Julian Shakespeare Carr, there was some bad blood. In the panic of 1893, Carr had foreclosed on Parrish's real estate investments, which ended up sold at sheriff's auction or in Carr's possession. Even though Julian S. Carr Jr. was one of the signatories to the chamber's incorporation, in 1907 the elder Carr formed a club of his own, first called "Cavaliers Club" and later reviving the "Commonwealth" name.

While Parrish's chamber numbered among its members an up-and-coming banker named John Sprunt Hill, school superintendent C.W. Toms and the younger Carr, the Commonwealth Club drew executives of the definitive Carr and Duke interests and spruced up its club rooms with card and billiard tables and its very own library. Overmatched, the chamber of 1906 faded from sight and was followed in 1912 by a new Commercial Club, with another Carr son, Claiborne, as its first president. It, too, was fizzling out within a year, but, despite problems keeping executive directors, Carr Sr. brought his prestige and personality to the rescue. The Commercial Club became an official chapter of the North Carolina Chamber of Commerce in 1915. To demonstrate its mind for progress, it opened membership to women in 1918—a year before women's suffrage became law of the land.

THE MIDNIGHT RAILROAD

When workmen were recently tearing up the downtown streets to make them all better again, they dug out some of the old streetcar tracks. That evoked a certain poignancy because enlightened citizens in Durham, as in other places, have clamored that what cities of the twenty-first century need is a dose of the nineteenth—that is, communal modes of getting around, like the streetcars used to be.

Enquiring minds ought to know that streetcars gave cities troubles of their own.

To mention one contemporary concern, Durham's first streetcars did nothing to alleviate air pollution, for they were powered not by clean (if coal-fired) electricity, but by horses and mules whose leavings provided work for

not only street-sweeping crews (were the aldermen of minds to fund such), but also flies, and filtered down into the water table helping Durham win an image as a hotbed of typhoid (a.k.a. "Durham fever"). The Durham Street Railway Company began in 1887 with a line from Blackwell Park to Dillard Street. The raised tracks running down the middle of the primary avenues, however, presented a hindrance to other forms of conveyance, and their maintenance proved such a problem that by the mid-1890s the city was threatening to revoke the company's franchise.

Owners Richard Wright and Julian Carr Sr. responded by promising to electrify the system. In 1901, they formed the Durham Traction Company and laid new tracks, running from the mill village of West Durham to the mill village of East Durham along Main Street and, diagonally, from Trinity Avenue on the northeast to Maplewood Cemetery. The new system encouraged growth, planting streetcar suburbs in still-rural areas on the edge of town. On the east end of the line, the Traction Company built a baseball park, and on the other, just past the cemetery, the Lakewood amusement park. In hot weather, patrons would gladly pay a nickel to ride all day in the cool breeze created by the breakneck speed of six miles per hour. All that came only after the company surmounted some more difficulties.

One of the Durham Traction Company's streetcars at the gate to Lakewood Park. The streetcar company built the amusement park at the end of one of its lines. *Courtesy Lakewood Park Community Association.*

Durham's horseless trolley was scheduled to make its first trip on May 23, 1902. Spectators, unconvinced any such newfangled contraption could actually run, were on hand and must have felt confirmed in their skepticism when the first cars started off—and stopped dead on their tracks. Just in time, the company's power station had broken down. A team of horses had to be summoned to tow the electric cars back to the car barn, and one unsympathetic fellow was so unkind as to stalk into the Traction Company office and say, "I hope you smarties are satisfied."

It wasn't until June 2 that the company felt bold enough to try again, but then the cars worked and served well for twenty-eight years—until they, in turn, were replaced by internal-combustion efficiency. Since the tracks were built on a thick concrete base, the only thing to do with them was pave them over, though during World War II most of the rails were recovered and recycled for armament use.

Streetcars were hardly the only form of moving freight and folk from place to place that gave our growing town difficulties. The town may have been the result of the railroad, but, business being business, train service itself had become problematic within thirty years of arriving. Durham was served by only one line, a branch line at that, and the leasing Richmond & Danville company operated the line like the monopoly it was. Even so boosterish a spokesman as Hiram Paul complained, writing in his book that rail service was far from adequate and the depot itself "a reproach, there being no reception room for either ladies or gentlemen, and the apartment used as such…being so filthy and offensive that ladies never apply for tickets, except in cases of absolute necessity."

Clearly, competition was called for, and Durham's chieftains of commerce were up to the challenge. By 1886, they were promoting bonds to finance a new line:

> Let us…determine that before another summer's sun the shriek of the locomotive, echoing from hill to hill in the county of Durham, shall announce to your people that our work is done and it is known as the Durham & Roxboro R.R., owned and controlled by our own people and not a foreign corporation.

It was not as easy as it looked at first. No sooner was the new Durham & Clarksville road, running northeast into Virginia, completed in late 1888 than its backers leased it to the Richmond & Danville, as well. A third line, the Durham & Northern, was completed March 26, 1889, but it had a problem of its own. Its right of way terminated at the eastern edge of

town, near Dillard Street, and that was a far distance from the Blackwell and Duke tobacco factories that had been built along the original tracks now controlled by the R&D, and that firm was in no mood to share with or otherwise accommodate a rival.

So, the town's good aldermen, acting with the general welfare at heart, gave the Durham & Northern the go-ahead to lay its own track to the factories, running it right up Peabody Street, which paralleled the existing rail line on the north side. The trouble was that Peabody Street lay inside the old North Carolina Railroad right of way that the state had leased to the Richmond & Danville. Anticipating opposition, on April 9 a crew made up of townsmen went out in the dead of night and began making tracks. By the dawn's early light, the R&D had them arrested for trespassing.

The town authorities, however, promptly dismissed the trespass charges and the Durham crew was back at work as soon as darkness fell. By the time the sun came up again, the "Moonlight Railroad" was complete all the way to the W. Duke Sons & Company factory on the western side of town. The workmen went home for a well-earned rest, and the Richmond & Danville's hands began tearing the new tracks apart. Town police stepped in. Both sides summoned legal counsel, and while the matter awaited the pleasure of the courts, townsmen stood armed guard over the line they had drawn, so to speak, and the Durham & Northern parked freight cars all the way through town to dissuade anyone from messing with its track. The Richmond & Danville tried to lay connecting switches to move the cars out of the way, but in May a federal judge told it to leave the D&N alone. The R&D complied, but its attorneys labored on.

It had not yet been determined to legal satisfaction just who had the right to do what with Peabody Street. In 1890, a court ruled that, when the Richmond & Danville had leased the North Carolina Railroad, authority over Peabody Street reverted to the city. In 1895, the Southern Railroad bought the R&D and dissolved the company, thereby, the Southern claimed, voiding the reversion. In 1903, a federal judge agreed and so obliged the Seaboard Air Line, which had bought the Durham & Northern in 1901, to pay the Southern rent for use of the Moonlight track.

That decision only set up another contest of wills. While the city, the D&N and the R&D faced off, a third line, the Durham & Roxboro, had been completed to Ramseur Street on the east side. Rather than deal with the R&D and its attitude, or the D&N and its legal problems, the Duke principals, who had put up $100,000 of their own money for the Durham & Roxboro's construction, skirted the situation by laying a beltline from their factory, around the northern edge of Durham, to the Durham & Roxboro

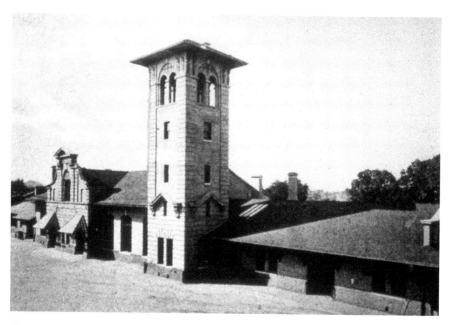

Union Station opened in 1905 after an act of the state legislature forced the five railroads serving Durham to share depot space. *From* City of Durham Illustrated.

track just outside town. (In 1899, the Durham & Roxboro was bought by the Norfolk & Western.)

The Norfolk & Southern soon joined the mix with a freight route going south. Each railroad maintained its own station facilities. The inefficiency grated on the customers of all four lines, who, by the new century's beginning, were clamoring for the companies to share one "union" station. The railroads, especially the aggressive Southern basking in the light of its legal triumph, were cool to the idea, but Durham legislator Jones Fuller contrived to maneuver the state legislature to decree that, where two or more railroads served the same town, they could be compelled to share a depot.

So blessed, in 1904 a Union Station Company began constructing a new depot in Durham, to serve the N&W, N&S, Seaboard and Southern. That very year, the Southern applied to build a side track along Pettigrew Street, which paralleled Peabody on the south side of the tracks. The town said no. The railroad not only went to court, but this time also set nocturnal crews of its own to work, laying track along Pettigrew and, just to rub the court's earlier ruling in the city's face, along Peabody as well. The city got an injunction, the railroad sued and eventually, this time, the nonsense was thrown out of court.

Through this episode in March 1905, the new station, complete with Italianate tower and intricate decorative brickwork, stood waiting for business—while the Norfolk & Western worked out its own right of way dispute with the town of Durham, which had blocked that company's track at Chapel Hill Street. Cool heads prevailed, deals were struck and Union Station opened to general fanfare and festivity on May 1, 1905. A mixed train—passenger and freight—of the Southern was the first through; later in the day, baseball fans streamed through on their way to the hometown team's game in Raleigh.

In time, pigeons took over the tower. Coal grime and grease settled over the building. Wear, tear and passing passengers took tolls of their own, and traveling tastes changed with the times. Rail passenger service to Durham ceased in 1965, and three years later the iconic Union Station fell to another era's best and brightest ideas of highest and best use. Durham tore down the station and put up a parking lot.

THE HOLIDAY

It was a simpler time back then. Durham had its Union Station and the railroads were at peace, so come November it was time for giving thanks. Thanksgiving Day 1905, in fact, was a quiet one in town. Nettie Watts and William Carden, an East Durham couple, ran off to get married in South Carolina, and businessman James Southgate received due honor for founding the local Masonic Lodge. A crowd did gather at the drugstores, where play-by-play reports from the University of North Carolina's football game against Virginia in Norfolk came in as quick as eight minutes after the action via long-distance telephone. North Carolina won, 17 to 0. Elsewhere, a man was caught stealing eggs, two women were arrested for selling whiskey and, out in the county, a Bible and a flag were presented with appropriate fanfare to the Redwood School.

The quiet was, no doubt, welcome. In the week leading up to the holiday, when an African American passenger on the streetcar was ordered to give up his seat to a white woman and child, another black passenger exclaimed, "I'd die right here before I'd get up and give my seat to any poor white trash!" A white commentator used the incident to make a case for Jim Crow laws. Reverend W.S. Elam of Orange Grove Baptist Church pulled a pistol and fired on Dave Lyon, who had threatened Elam with bodily harm for kicking him out of the congregation. But Ernest Womack would have cause to give thanks, for the charges against him, for accidentally killing Cornie Marks

with an antique rifle two weeks earlier, were dropped because the arrest warrant had been filled out incorrectly.

Then, once Thanksgiving Day was done, the Christmas buying season sprang into full gear. The Ellis, Stone & Company department store promised "one of the greatest fur openings…ever attempted in Durham" while the W.H. Proctor dry goods emporium advertised "Christmas Goods and Fireworks." Speaking of fireworks, on Saturday Jack Shambly and Dick Sykes went to court for an "affray" with deadly weapons but were discharged for insufficient evidence. That same day, one Jackson Emory, who had disappeared without a trace seventeen years before, was spotted in East Durham. He was reported to be visiting friends but made no effort to call on his "widow."

The Sign

In the 1980s, the city council dithered for months over what welcoming slogan to paint on a water tower overlooking the freeway that leads into town from the airport. It ended up painting nothing. That's a story we will return to later. That was not the first time Durham felt moved to proclaim itself to passing traffic. First, there was the Slogan Sign, and its introduction was occasion for soaring oratory and special sales at the downtown stores. It was Christmastime, December 15, 1913, and Durham greeted the season with bright color in the form of 1,230 electric bulbs casting a five thousand-candlepower glow, declaring "Durham Renowned the World Around." This was mounted on a skeletal framework forty-one and a half by thirty-one and a half feet in size, perched atop the telephone exchange building in ready view of all trains passing a block away.

The wording was a combination of suggestions from J.E. Banning and Mrs. W.W. Weaver, who shared fifty dollars for their inspiration. Constructed by the Greenwood Advertising Company of Knoxville, Tennessee, the sign flashed "Durham," in electric letters four feet tall, followed by "Renowned the World Around" in two-and-a-half-foot letters and then "Progress," "Success," "Health" and "Wealth" around the sign's perimeter. A red globe appeared to rotate, and a double border of red and white lights stayed lit as long as the power was on.

The monstrosity was a project of the aforementioned Commercial Club and the Durham Traction Company, which had diversified from streetcars to powering the whole town. In 1913, the company was promoting electric signs for businesses and, to show what it had to offer, donated one to benefit the city's image. Illumination was scheduled for a Sunday night in shopping

The Slogan Sign by night. Using 1,230 colored bulbs and five thousand candlepower, the sign first blazed forth for the Christmas shopping season in 1913.

season. The railroads ran special excursions into town. As darkness fell, an estimated ten thousand people had jammed the streets in anticipation.

A local newspaper set the tone:

> *This will be the most stupendous undertaking in Christmas decorating that has ever been undertaken in this section of the country, and if there is any other town in the whole country that has ever done anything of this kind the reports have not reached the local people. Just as a good housewife would decorate her home for the Christmas holiday or a merchant would decorate his store for this annual event the whole of the business section of the city will be wreathed in the green and white of the Christmas season.*

Opening the proceedings, Mayor W.J. Brogden continued in the same vein: "The knowledge of our own possibilities has come to us, as it were, as an echo," he said. "We have been slower to recognize our own advantages than the stranger who has passed through our gates, yet, in spite of herself, this, the youngest city in the state, is known wherever the human race exists."

The weather was splendid. Santa Claus arrived on the 7:55 p.m. train and rode, blowing kisses and waving, upon a fire wagon as he led a "tacky" parade of costumed revelers who marched and countermarched along Main Street beneath Durham's first strings of Christmas lights. The Traction Company had given out horns, and their noise, along with that of other instruments, drowned out most of the speechifying. Fortunately for posterity, some remarks were committed to paper, such as these of the Commercial Club's W.G. Branham:

> Some 2,000 years ago there appeared in the eastern canopy of heaven a brilliant light in the form of a star, which advertised and proclaimed to the wise men of the east the greatest event of all time. From that time to this splendid hour, men have vied with one another to produce some novel plan by which to proclaim to the world their achievements.
>
> Astronomers tell us that the planet Mars is inhabited and possibly other planets. We do not know whether our fame has as yet reached their celestial shores, or not, but there has been erected on one of our large business buildings one of the largest, most brilliant and artistic signs south of Washington, the gift to the Commercial Club of Durham by one of our public spirited public service corporations, that Durham may be, as she is now, renowned the world around, the celestial planets included.

Then the time came to light up. Mayor W.J. Brogden flipped the switch and hundreds of shining, flashing, shimmering bulbs came on—all except the ones that spelled out "Durham."

Perhaps it was a faulty circuit. Perhaps the spirit of the town was just plain embarrassed. Whatever the cause, long and pregnant minutes followed as the natives grew restless and began to chant, "Let's have Durham!" and "Where is Durham?" But at last, the connection was made, electrons flowed, "Durham" blazed forth in all its glory and a cheer rose to the heavens.

While the Martians gave no indication of having noticed, the sign did have some of its desired effects. Five more businesses bought electric signs by the next July, raising the town's grand total to nine, and the Traction Company's promotion got a few words in *Electrical Merchandise* magazine, along with an advertisement by the Greenwood Advertising Company. Its career, however, was brief. A windstorm a few years later wrought considerable damage, and in November 1919, a committee of the chamber of commerce—into which the Commercial Club had by then reorganized itself—estimated replacing it would cost $2,250 and recommended indefinite postponement.

A Golden (-Leaf) Age

THE WRITER

Over in Chapel Hill, they still make much over Thomas Wolfe, the hulking (six feet, five inches) character who passed through the University of North Carolina on his way from Asheville in the mountains to literary celebrity and an early death—the symbolism of which Wolfe, likening himself to Achilles, might have appreciated.

Wolfe left a reputation and his words—oh, lots and lots and lots of words—and while he is chiefly associated with his college and the home that he could not go back to, some sifting in the verbiage finds that Durham, too—which he called "Exeter" in *Look Homeward, Angel*, his thinly fictionalized version of how-I-came-of-age—made a lasting impression on the young man.

Wolfe, who called himself "Eugene Gant" in the book, would get off and catch the train in Durham/Exeter on his way to and from college at "Pulpit Hill." Wolfe/Gant entered the University of North Carolina/Old Catawba in the fall of 1916. Durham was a booming place, and the city fathers had erected the Slogan Sign to say so, lest anyone forget or have been so out of touch not to have heard. Wolfe would have entered Durham by way of the still-new Union Station, and Durham entered literature, in *Angel*'s twenty-eighth chapter, as "the dreary tobacco town of Exeter."

Such was the impression it made as young Eugene came down to college for the very first time. It got worse in the next chapter, when Wolfe's alter ego is introduced to the pleasures of the flesh. Indeed, in *Look Homeward, Angel*, going to Exeter is a euphemism for going out for sex. Eugene is tempted, falls and pays the price—by the time he goes home for Christmas vacation, "his loins were black" with Exeter vermin.

In real life, Wolfe would have probably paid many visits to Durham to bring the student newspaper, the *Daily Tar Heel*, for printing. Wolfe was the paper's editor. Yet, in all Wolfe's work, the larger town only appears in terms of "drab autumnal streets…squalor of cheap houses…the foggy air was full of chill menace…brooding quietness…a sordid little road, unpaved, littered…a world of rickets."

Since the time of Pinhook, the boys from Chapel Hill had frequented the fleshpots along the ridge, and Wolfe was simply following a university tradition. Where Exeter was raw and dangerous and dark, Pulpit Hill possessed a "rare romantic quality of the atmosphere…thick with flowers and drenched in a fragrant warmth of green shimmering light."

In the book, Eugene Gant leaves Pulpit Hill with the implication that he is gone for good. In life, Wolfe went on to Harvard and, with the uproar his tell-all first novel stirred in the state he had left behind—Raleigh publisher

Jonathan Daniels said Wolfe had "spat upon the South"—he, too, was reticent to come back. Could he come back today, no doubt, he would find much had changed. Or maybe not.

The Missionary

In the bully age of Teddy Roosevelt and the Great White Fleet, Julian Carr even had a hand in molding the nation's foreign affairs. Whether he realized it or not.

Carr was a devoted Methodist. While Julian Carr Street has been absorbed into a parking garage next door to his old Bull factory, to this day an adult Sunday school at Trinity United Methodist Church (the same congregation once burned out in Dilliardsville) is called the "Julian S. Carr Bible Class." As a Methodist on the make, in 1881 he was contacted by Braxton Craven, president of the denomination's small and struggling Trinity College, about a young man who showed great promise in the missionary field but needed some training and polish and, more to the point, a patron to pay for it.

Carr's spirit was moved, and so, in April of that year, he received into his home one Han Shao-chun, fifteen-year-old son of a well-to-do southern China clan who had run away from learning the family tea trade in Java to see the wider world. Shao-chun, whom the world would come to know as tycoon and power broker Charlie Soong, had landed in Boston, wearied of working in a cousin's import-export business, stowed away on a U.S. Coast Guard ship, and became the ship's mascot and the ward of Captain Eric Gabrielson. Under the captain's influence, he accepted the Methodist persuasion and, upon the captain's retirement, came into the charge of the Reverend T.P. Ricaud of Fifth Street Methodist Church in the port town of Wilmington, North Carolina.

By now going as "Charlie Soong"—the closest his shipmates could come to pronouncing his Chinese name—the young man impressed all with his industriousness, piety, smarts and personal charm. Just the kind of man, Ricaud thought, to lead half a billion Chinese heathens into Methodist sanctification. Ricaud contacted Craven at Trinity, then in a rural district about eighty miles west of Durham, and Craven agreed to Charlie's matriculation if the money could be found. Carr obliged, and from spring until the fall term began Charlie charmed the Carrs and the rest of Durham. On ship, he had learned to make hammocks, and he practiced the trade in Durham to keep himself in spending money. That impressed the town's go-getting business class, while Charlie's manners impressed the town's young ladies.

Charlie Soong, born Han Shao-chun, in his college days. The future Shanghai entrepreneur and revolutionary spent formative time in Julian Shakespeare Carr's household.

At school, Charlie was exotic—the first "Celestial," indeed the first foreign student that Trinity had ever seen. He was popular and, from his letters, had a good time all around until his way as a ladies' man got him caught in a compromising position with a faculty member's daughter by the faculty member's wife. Charlie's transfer to Vanderbilt University was quickly arranged, and in Nashville he finished his schooling and, while keeping in close touch with Durham friends, especially one Annie Southgate, set out to accomplish the Lord's work back home.

It did not take long for Charlie to get frustrated in the missionary business. For one thing, his missionary superiors were prejudiced against his race and, for another, the pay was lousy—especially after Charlie married into a wealthy family of Shanghai entrepreneurs who opened new vistas to him. Having learned the printing trade in Wilmington, Charlie opened a business to publish Chinese Bibles and missionary tracts—and, on the side, political tracts for the revolutionaries who flourished, along with the rest of Shanghai's underworld, in the foreign-trade zone that was hands-off to the native police. Charlie did well. He kept his business to himself, for not doing so could have meant his swift and unpleasant demise, along with that of the rest of his family, at the hands of displeased associates, but it is known that he expanded the printing company and invested in cotton and tobacco factories. Charlie rode to his office each day in a private rickshaw from a suburban home he had built in Old South style to remind him of his roots in Carolina. He and his wife had three sons and three daughters; the boys he sent to Harvard, the girls to Wesleyan College in Georgia. He also became best friends with a revolutionary figure named Sun Yat-sen and treasurer of Sun's Young China political party. He put his own money into the party's accounts and traveled to raise more. In 1905, he paid a call in Durham.

Much had changed since 1881. The town had running water, two hospitals (one white, one black), electric streetcars and a college, Trinity having come in from the country in 1892 and settled on the former Blackwell Park (which Carr donated, having acquired the land through Blackwell's bankruptcy proceedings). His patron had prospered even more and, having decided his original mansion on Dillard Street, Waverly Honor, was not grand enough to suit a man of his standing, Carr had it moved across the street for the use of a poor relation and built a new, bigger, fancier home that he called Somerset Villa. Each day, Carr wore a flower in his lapel fresh from his private greenhouses. No doubt impressed, Charlie regaled the pious Carr with tales of China's plight—how the imperial Manchus oppressed the people, how good Christians were persecuted. What was said was not recorded, but it is documented that Carr and Charlie had a long, late-night conversation

behind closed doors at Somerset Villa and, when Carr himself paid a visit to Charlie in 1914, after Sun's successful revolution, the new ruling class received him, he said, "royally, like a king." Or, one might conclude, like a Hero of the Revolution.

Charlie's children made marks of their own. One daughter, Ai-ling, who had been Sun's secretary, married H.H. Kung, wealthy and a direct descendant of Confucius. Younger daughter Chin-ling married Sun himself. Daughter Mei-ling married the military boss of what was now Sun's National People's Party, or Kuomintang—a former Shanghai thug named Chiang Kai-shek who took over most of the country after Sun's death. Their brothers took high positions in the new order, T.V. the nation's finance minister, Tse-liang a top tax collector and Tse-an the Shanghai harbor boss.

Family harmony fell to politics, though. In a gesture of solidarity with financial interests, Chiang executed 3,500 Chinese communists who, with Russian tutelage, had helped him seize power. Chin-ling considered that a betrayal of the revolution and left for Moscow, where she joined up with yet another Chinese revolutionary, Mao Tse-tung. In later life, she was called the mother of Mao's revolution, which threw out Chiang, his party and his wife in 1949. Mei-ling became world famous as Madame Chiang, the dragon lady of international anti-Communism who shaped American policy toward China until 1972, when the ice was broken by then U.S. president Richard M. Nixon, who had himself come to power by way of Durham, as a law student at Charlie Soong's first American alma mater, which by Nixon's time had graduated into Duke University.

PART IV

BULL CITIZENS YOU SHOULD KNOW

Throughout these stories, I have been writing about people: William Johnston, Dr. Durham, Julian Carr. People, after all, are what make the stories of how a place came to be what it is and why it is. Some are founders, some are builders, some are rich and some are famous, and most are just plain folks. Really, it's the just plain folks who leave their marks where they count. They don't have to leave their names on streets or buildings. They don't need to make money or lead great efforts toward civic betterment. They just leave the old hometown the better for their having passed through—and leave themselves in those whose lives they touch.

THE BEST DUKE

Washington Duke founded the tobacco company; his children—Brodie, Mary, Ben and Buck—built empires. There was another Duke, though, and some who knew him said he was the best of the whole bunch.

That was Uncle Billie. He was Washington's older brother, a farmer, a preacher and a character who rests by the church he founded: Duke's Chapel. Now, that is not to be confused with Duke Chapel, the towering neo-Gothic edifice on the university's West Campus; while built of the same gray stone and in a similar style, Duke's Chapel is a humbler house of worship out on the Old Oxford Highway near the land that Uncle Billie cultivated and his old homestead. The homestead is gone, removed to make way for a subdivision. The road it stood on once was called "Duke Lane," but now the name is "Danube" just to avoid confusion with the Duke Street thoroughfare or Duke University Road. But Uncle Billie is still remembered.

William James "Uncle Billie" Duke helped raise his younger brother Washington and passed on his brand of circuit-riding Methodism. *Courtesy Duke Homestead State Historic Site.*

Bull Citizens You Should Know

Uncle Billie came into the world as William James Duke on July 18, 1803, first of the ten children born to Taylor and Dicey Jones Duke, who owned a small farm on the Little River in northeastern Orange County. Taylor Duke was prominent in his own right, a captain of militia and a member of the Democratic Party's local "committee of vigilance," well-to-do enough that his five-room home had glass in its windows. His own father, similarly, may have been a man of standing, for the Methodist evangelist Francis Asbury, in the journal of his first foray through backcountry North Carolina, recorded that on June 21, 1780:

> *I had to ride alone better than 12 miles to Mr. Duke's; when I came there, found about 30 people, and they quite ignorant. After preaching I took dinner, and in talking found three or four of them tenderly serious; gave them advice; the man and his wife have had conviction, and have sinned it away. They say it was the disputes of the Baptists that turned them aside.*

Methodism took hold in the Duke household. Young William met the Lord at a church picnic and then, as a grown man, heard the call himself, joining the company of circuit-riding preachers who spread hellfire, brimstone, hymn-singing and salvation to isolated pagans, lonely brush arbors and camp meetings in the seasons when crops could be left to grow on their own. Setting out on his own around 1825, he married Sarah Roberts and began buying land, but every Sunday he and Sarah would travel, their babes in arms, five miles to their home church, Mount Bethel. The hike must have begun to wear on them, though, for around 1836 he built a brush arbor of his own on the Roxboro road at present-day Denfield Street. Some folk still know the intersection as "Old Hebron."

By the time Billie left home, his parents were in financial straits. Billie took in his little brother Washington and taught him farming, religion and abstention. When Billie founded the Mount Hebron Temperance Society in 1842, the twenty-one-year-old Washington was one of its committeemen. That was also the year Washington married Mary Caroline Clinton and received some acreage of his own from his father-in-law. They had two sons, Sidney in 1844 and Brodie in 1846, but in 1847 she died, leaving Washington to raise the boys and run the farm alone. He managed for five years. In 1852, he went along with Billie to a revival one county over. At Mount Pisgah Church in Alamance County, he met a beauty named Artelia Roney—descendant of an eighteenth-century evangelist known as the White Pilgrim. They married in December. Artelia bore three children: Mary in 1853, Benjamin Newton in 1855 and James Buchanan, "Buck," in

1856. The children learned to work under their uncle's tutelage. It was Ben and Buck who started calling William "Uncle Billie."

Uncle Billie was also known as "Squire," for his landholdings grew to 640 acres, and as "Uncle Billie of the Old Ship," for his favorite hymn, "The Old Ship of Zion." People said he could take off the roof when he sang it and out-preach anybody in the county. "He never made the money Wash and his boys had," one said, "but Billie was the best of the Taylor Duke lot." He inveighed against the devil, including liquor, though he did like a little nip of apple brandy, and he chewed tobacco but never failed to expectorate it before going in to preach. Once upon a time, a slicker tried to sell him some insurance. "I'm not interested," Uncle Billie said, "but if you've got some insurance for my soul, I'll talk to you."

The Hebron congregation grew, and talk began about moving and building a bigger church. Billie Duke donated some money, but before the move could be made he went to his reward. It was 1883, and he was buried in a family plot near the Eno River. And there he remained until 1990, when what had become Duke's Chapel United Methodist Church approached its 150th anniversary and members figured a fitting way to mark the occasion was to bring Uncle Billie to his namesake graveyard. His body was exhumed and reinterred—or so everybody thought.

In 2003, a developer planning to build on the land where Uncle Billie had been first buried published his intention "to Disinter, Remove and Reinter Graves" before constructing a subdivision and hired a removal firm to dig the remaining bodies out. As the workmen dug around where Uncle Billie was supposed to have been exhumed, they found about two feet down some modern Coca-Cola bottles. Apparently, the 1990 diggers got tired and bored, decided they wouldn't find anything anyway after 107 years, tossed down their drink bottles, replaced the dirt and delivered Uncle Billie's tombstone to Duke Chapel. Nobody would be the wiser, they figured.

It must have seemed like a good idea at the time, but when the truth came out Uncle Billie's descendants were furious. So another crew was set to work and, going down the full six feet, found some ornate metal casket parts, some shards of glass, bits of bone and a few fabric scraps. That much of Uncle Billie was removed to go beneath his tombstone. And so he remains, while on the other side of town a university and hospital are the legacy of that little brother and the niece and nephews he helped to raise.

"A man of upright character, of deep religious faith, a revered patriarch of his day," parishioner Amy Fallaw wrote in *The Story of Duke's Chapel*. "He left a wonderful heritage."

THE SPORTSMAN

When Al Mann hung up his whistle, he took something out of fall. When Al Mann departed this life, he left a lot of good behind.

Husband, father, grandpa, churchman, veteran, boxer and inspiration to fifty-seven years' worth of little boys who came under his influence, not to mention their parents. Al Mann played many positions, but the one that left the greatest impression, one might argue, was Al Mann, football coach.

For generations, Saturday mornings meant a flat at Forest Hills Park that Al and his sons Craig and Randy and, in later years, grandson Jeff, had marked off into a miniature gridiron for "towel football." It was a variation on flag football that Al cooked up when he was a navy physical-training coach in World War II, using tightly rolled towels tucked under tightly cinched belts—grab a towel and pull it loose, the ball carrier is down.

It wasn't as easy as it sounds. Al taught football fundamentals: blocking, "tackling," stances, formations, plays, confidence and teamwork. Moms who were paying attention usually learned a lot. The main thing Al tried to instill, though, wasn't in knowing when to pull left or how to read a quarterback's eyes. It was sportsmanship, which he summed up in his trademark slogan:

Al Mann coaches on the sidelines during a championship game at Forest Hills Park, November 1994.

"Win without crowing, lose without crying." Don't brag, don't gloat, don't whine and don't make excuses. Shake hands and appreciate the other guy. Al himself was a case in point.

In his youth, Al was a boxer, and a very good one. As state Golden Gloves champion, he fought in Madison Square Garden. In college, he finished third in the NCAA in 1936—when college boxing was up there with college football in stature and popularity, when pugilism drew bigger crowds at Duke University than basketball. One time, in front of those crowds, he had a close bout that came down to the referee's call. The ref called it, the crowd didn't like it and the atmosphere quickly turned ugly. So ugly that Al was afraid for the official's welfare. So Al put his arm around the referee and escorted him out of the gym, notwithstanding that the ref had just called Al the loser.

"It just seemed like the thing to do," Al said years later.

Al and sports were a combination early on. Growing up in the 1920s, out in the country on the road between Durham and the college town of Chapel Hill, Al and his brother Wilton heard that a builder wanted boys to help move debris where he was clearing land across the road for a swanky subdivision and golf course. You drove mules and horses, worked ten hours a day and by Saturday night you'd have seven dollars in your pocket. Good deal.

Along the way, they learned what golf was and that boys could make thirty-five cents for caddying nine holes—just right for an afternoon after school, even better on the weekends. It was an education for them. They learned to be quiet and to pay attention and learned about people. Some would cheat, some wouldn't. Some tipped well, some didn't. Some would cuss, one just said, "Oh, my golly." Before long, they were playing the game themselves—along with baseball, basketball, football (sister Naomi got to play center) and boxing. The city recreation department brought a fighter down from Cincinnati to teach the sport to Durham youngsters, and every Friday night, out past the east side of town, they would set up a ring and the local champion would take on all comers.

Finishing college, Al went to work for American Tobacco and coached boxing as a hobby at a community center in Edgemont, a rough part of town. The idea was that boys would come in, work out, get tired and go home—instead of making trouble. The war came along and he went to serve, and when he got back to Durham, some prominent men in town asked him to teach their sons to fight. That led to front-yard football, then basketball as well. Boxing, in time, fell out of general favor, but the other games continued. All the boys—and eventually girls, too—got a trophy at

season's end for making first- or second-string "all-American." There was a trophy for improvement, too, but the top honor, given according to the kids' own votes, was for sportsmanship.

It went on from the late '40s until 1995, when, just weeks before the season was to open, Al realized his health just wasn't up to it any more. He said he might be OK by basketball season, might bring back football next year—but he wasn't and he didn't, and fall just wasn't the same ever again. It is safe to say that neither were any of his players after they spent a season or several in Al Mann's league. At home, he had every roster of every team, going back to the beginning—little boys who grew up to be doctors, lawyers, bankers, politicians, civic leaders, even one who argued a civil rights case before the U.S. Supreme Court and won.

It was sad when he hung up his whistle. It was sad when he passed away in early 2001. Sadness, though, is a self-centered emotion, and the ending of something that has been good—a tradition or a life—should be occasion for appreciation for what one has been privileged to share in.

A few years before Al retired, some of his former players held a dinner in his honor and had made T-shirts emblazoned with the Al Mann slogan. Some time later, one of Al's youngsters, in company with his parents, wore his shirt into an English tearoom. A lady there was impressed.

With a team readied for kickoff, Coach Al Mann moves out of the way of the game.

"Win without crowing, lose without crying," she read out loud. "I wish every boy could have that."

Quite an epitaph, that. Quite a Mann, too.

THE "MOM"

The historic preservation set refers to the old farmhouse at 326 East Trinity Avenue as the Geer House. Those who know it better call it Mom's. From the late 1960s until the late 1990s—a solid generation, that—326 East Trinity was home to Ruby Blackmon Planck, a.k.a. "Mom." Literally speaking, she was mom to just her own five kids, and the big old house was home to her husband, Chaunce, and four of the children (the eldest having moved to San Francisco back when hippies were still beatniks). Metaphorically, though, she was Mom and her home a sanctuary for an honorary extended family of in-laws, outlaws, mystics, mechanics, gypsies, geeks, poets, professors and plumbers.

In the '60s and early '70s, Mom was chief cook and bottle washer for the old Cosmo taproom above the Ivy Room restaurant midway between Duke University and downtown. That is where, with wit and wisdom and good conversation, she collected a clientele mixed of physicians and pilots; Environmental Protection Agency engineers and already-aging flower children; truckers, veterans, freaks, flakes; and some souls lost and some souls looking to get into that condition after reading too much Kerouac. The occasional undergraduate would get sent back to campus early if Mom knew there was a test in the morning.

After she retired, much of Mom's coterie followed to her kitchen on East Trinity, where she held court while suppers simmered, sizzled or set. "Durham" and "gourmet" were mutually exclusive terms back then, but Mom's repertoire ranged from Assyrian to Harnett County, and mealtime was as likely to mean dolmades as country ham. Between the street out front and the certified wildlife sanctuary out back, Mom's place was a cozy confine in the world but just a little outside it, too. Roger the Anglican/Catholic/Buddhist would wax metaphysical, and George the physiologist would wax emphysemic about antismoking attitudes. Don would talk about growing things, Elton about flying things and Phrog about blowing things up or reading to children.

The house was full of living things: dogs, cats, rats, fish, ferrets, plants and people. It didn't take much excuse for a party. The night Chaunce turned sixty, he was the last man dancing. Thanksgiving was occasion for true

Ruby "Mom" Planck with one of her wedding cakes, 1977. *Photo by David Williamson.*

feasting, and any wedding in the crowd called forth one of Mrs. Planck's splendid, towering cakes—even if, once, the slippery layers had to be held together with a cavalry saber. Poker games, cooking lessons and talk—about big bands in the '30s, wartime in the '40s (Chaunce had been in the second wave into Normandy), New Jersey in the winter and gardens in the spring and about books and writing and writers. Gathered around her kitchen table while something simmered on the stove, over coffee in the morning or Manhattans on Friday night, conversations ranged from Depression-era politics to the proper way of stuffing grape leaves, from media criticism to Buddhist theology and from growing peas and shrubbery to the power of the written word.

Mom loved writing, and she collected writers—real and wannabe—into her fold. She encouraged, cajoled, criticized and shared rejection slips, as well as her *Ladies' Home Journal* piece, to show that, yes, it could be done. Some of those fortunate souls went on to see their names in print in the bookstores, while others found there were other forms of creativity. For all, Mom remained a matron saint.

Ruby Planck was born in Duke (now Erwin), North Carolina, a hamlet south of Durham, on June 29, 1916. She was the youngest of nine children born to Norman and Mary Lee Blackmon and grew up in a succession of cotton mill towns. In Burlington, a leftist disguised as a Methodist Sunday school teacher recruited her to go for training as a political organizer in Moscow. Her brother Joe put a quick stop to that idea, but it was a story Mom liked to tell for years to come.

Mom would take on any challenge, especially if it involved cooking. In 1978, someone asked her, a one-time Southern farm girl, to demonstrate authentic, down-home, folky persimmon pudding for the Festival of North Carolina Folklife. She did it, for four hot July days and fifty thousand festival-goers—though theretofore she had never made persimmon pudding in her life, authentic, down-home, folky or otherwise. Mom's court endured, but all things end. The courtiers aged, some moved away and some passed on. Mom eventually gave up the kitchen and moved to a retirement home—all the way insisting that it was *not* a "rest" home. Right to the end, she kept her spirit, her wit and her sense of humor.

Not long before she died at the good old age of ninety-one, a preacher came to call. They talked for a while, then the good pastor said he'd be going since Miss Ruby looked ready to nod off.

"That," she said, "is because you're boring."

Bull Citizens You Should Know

THE BATBOY

When he was twelve years old, Jack Stanley had the best job in the world. He wore a uniform. He mingled with stars. He made one dollar per game and twenty-five cents for every pair of shoes he shined.

Jack Stanley was the Durham Bulls' batboy. It was 1962, he said, and at that time, "if you were batboy for the Bulls, you were the biggest kid in town."

Unfortunately, it didn't last long.

"Mom was always against the idea," he said. "Bad influences." But a neighbor had made the contacts for him, and Jack's dad thought it was great.

To appreciate how Jack himself felt, you have to understand that, for a Durham boy back then, baseball was what you did. A typical summer Saturday brought walking uptown to a cowboy movie, a hotdog at Amos 'n' Andy's, playing ball all afternoon and going to the Bulls at night.

"When we grew up, that was the national pastime," he said.

Boys' fields of dreams moved up from backyards to city parks as they graduated from Little League to Colt League to Pony League. If they were good enough to play American Legion ball, they actually played at Durham Athletic Park—"the Cathedral of Baseball" for Jack and his buddies, the hallowed ground where stars-to-be like Joe Morgan, Rusty Staub and Jose Herrera hit and ran and threw.

"We really looked up to those boys," Stanley said.

So there was twelve-year-old Jack Stanley, wearing his Bulls uniform to Carr Junior High School, retrieving bats and helmets, shagging flies at batting practice, "anything they told you to do"—even going up in the stands to fetch the cake "Ma" Gregory baked for the pitcher each Sunday.

And, of course, he was rubbing elbows in the locker room and the dugout, where "the guys" talked about swings and misses, "million-dollar baby" signing bonuses and trips up and down the farm system.

Other kids came to the ballpark for Long Meadow Night to get the free ice cream, or Greasy Pig Night, to chase a slicked-up porker around the infield and under the bleachers. ("I think that pig got beat up pretty bad," he said.)

Jack went there to work, however. As a batboy, Jack worked for trainer Fred MacNeil, an old-timer who had advice for boys among the "salty characters" of a baseball team: "Don't you ever take any of this home."

Jack Stanley's undoing was that he forgot.

He had been on the job just two and a half months when, after a game, he sat down to the family's Sunday dinner and said, "Would you please pass the damn butter beans?"

"My mom hit the ceiling," Stanley said. "My dad said that was a battle he wasn't going to fight."

Jack was still wearing his uniform.

"Having to turn in that uniform was a bad day in my life," he said. "That ended my career…Broke my heart."

He did keep playing ball, through high school and a year at Louisburg College. He graduated from UNC, became a salesman, then a supervisor for Liggett & Myers and then started his own bulk mailing business. But there was nothing like being a Bull batboy.

"To my dying day," he said, "that's the best damn job I ever had."

THE GARDEN SPIRIT

Virginia T. Watkins reigns at Hope Park, a benevolent soul. People who work in or just observe the park may feel her sharing in their pleasure.

Virginia Watkins died January 15, 1995, at the age of seventy-eight. Her earthly remains are a couple of miles away in a cemetery, but her spirit lies over an eighth of an acre by the freeway and near the new ballpark, behind the high-rise Henderson Towers apartments for folks who are getting on in their years. The night before she died, she told one of her neighbors she wanted that park to be there—be there after she departed.

The park was all Virginia's idea, and she set her stubborn self to work to get a vacant lot full of weeds and rocks turned into a restful spot of lawn, trees, shrubs, flowers and vegetables—with a stone slab in Virginia's honor set into a gentle rise between two pine trees where she would have a good view from which to keep an eye on her realm.

Virginia set a tone for herself almost as soon as she moved into the towers. She started planting roses in memory of each resident who passed away. When the weather was dry, she would bring down jugs of water from her apartment way up on the ninth floor to keep the roses healthy. People who didn't care about other people bothered her; she tried to love and be loved, and her attitude was infectious. Not that she couldn't be tough when the situation called for it—even to the extent of balling up her fist and grinding it against a cheek to make her point.

She charmed the West Durham Lumber Company into donating plants and a class of fourth-grade children into donating time and work. A service

Stone marker commemorates Virginia Watkins's driving spirit behind Hope Park at the J.J. Henderson apartments. *Courtesy of the author.*

club came along to help, the Boy Scouts, a gardening nonprofit—old people, kids, all kinds of folks joined in. Henderson Towers itself appointed a garden committee. A few months after Virginia passed, her neighbors held a ceremony to unveil her stone.

They could tell that she was pleased.

PART V

MODERN TIMES

No less than our town's origin myths and lore from the gilded-leaf decades, our communities' twentieth century tales have added characters, quirks, depth and curiousness to the greater history. The first decade of the 1900s saw African American capitalism take root in the middle of the uptown business section, where the North Carolina Mutual insurance company built its office and leased space to the Mechanics & Farmers bank. In 1910, black dentist and missionary James Shepard founded the National Religious Training School and Chatauqua, and when it later encountered difficulty staying in business, he maneuvered the state into taking it over and reorienting it as North Carolina College for Negroes. It's a regular university now, with expansion plans and neighbors aggravated about it.

The '20s brought Buck Duke's Endowment, which he set up in Charlotte (headquarters of his electric power business) while giving the old hometown (where he hadn't lived since 1884, preferring the society of his peers in New York City) a boost with some millions for little Trinity College if it would just change its name to honor Buck's ol' daddy. Buck had the old campus totally rebuilt, another campus built from scratch a mile and a quarter away (so as to put the screws to speculators who had been snapping up property around the Trinity campus in expectation of his generosity) and soon thereafter died, leaving the school even more.

Thus empowered, Duke University went out in Depression times to hire the brightest academic stars that money could buy. It even hired a coach from Alabama, Wallace Wade, who made the school famous for football (lost the Rose Bowl in '39 and again in '42). It hired a young psychologist, J.B. Rhine, who made the school famous for his experiments in mind-reading, for which he coined the more academically respectable term "Extra-Sensory

Perception." It hired a German Jewish refugee physician, Walter Kempner, who, while treating patients for hypertension, discovered that a paltry diet of rice and vitamins did wonders for their weight. Kentucky Fried Chicken's Colonel Harlan T. Sanders, Lorne Greene of television's *Bonanza* and, legend holds, Elvis the King himself came to our town to partake of Kempner's "Rice Diet" and made Durham famous as "Fat City."

The new century brought innovations in less intellectual fields, as well.

THE GAMESMEN

The sporting life has always been important to Durham folk. What became the first public cemetery might have been a baseball diamond but for some stubbornness on the part of aldermen and an accident with a cannon. The national pastime was not long to come in Durham, though, for by 1875—just three years after Louis Austin was laid to rest—a Durham baseball team was taking on the Eno Bottom Rangers of Hillsborough. Durham lost, 18 to 26, but the rivalry went on.

However, players of those early years had much to learn about conditioning and nutrition. After another Durham-Hillsborough game, in 1880, Durham player George Lipscomb overindulged in ol' redeye while giving the proverbial 110 percent on the sunny field. That night, he suffered what was thought to have been a stroke. He fell unconscious and died the next morning. His death notice concluded, "The weather is too hot to mix whiskey and baseball."

The gentlemanly pastime of golf arrived soon after the new century, after John Sprunt Hill—a University of North Carolina graduate who went north and did well for himself as a lawyer for Tammany Hall—married Annie Watts, only child of tobacco magnate George Washington Watts, and was induced by his new father-in-law (who hated to think of his daughter so far away and among such Northern people) to come settle in Durham and start banking with some of Daddy George's money. Hill knew a good proposition when he heard it, came back south, started not one but two banks and bought some land in the country, where he had built for himself a nine-hole course.

Hill had learned to like the game in New York. Of course, he had to sell some others on it so he would have someone to play with, and so in 1912 he helped form the Durham Country Club. The club went broke shortly, but Hill reorganized as the Hillandale Golf Club and operated it until 1939, when he, benevolent spirit that he was, donated it to the city "for general

recreational purposes by the white citizens of Durham." Hillandale Golf Course remains in business today, as does the Croasdaile Country Club on another piece of Hill's property.

Nowadays, if Durham has any "renown the world around," it probably has a sporting connection—like by way of the movie *Bull Durham*, produced by homeboy Thom Mount (who owned a piece of the real Durham Bulls at the time) and released in 1988 with a hometown premiere. The actual Bulls have moved up from the bottom-of-the-bush-league bunch of the picture and the A class of the '80s to AAA status, and to a fancy new park across town from the one in the movie, but the town's image boosters cash in on *Bull*'s success (somebody is supposed to have rated it the number three all-time date movie) every chance they get, letting bygone be the original billing: "A major-league love story in a minor-league town."

Or renown might be by way of basketball, a game at which the universities of Durham have enjoyed some success—four national titles between North Carolina Central (NCAA Division II, 1988) and Duke. Basketball has no such long pedigree in town as baseball, though. In fact, when the first game was played in town, its report had to compete for newspaper coverage with a high school debate.

It was March 2, 1906—about the time of year when, today, all the talk is about "brackets" and "bubbles" and "beer." Wake Forest College,

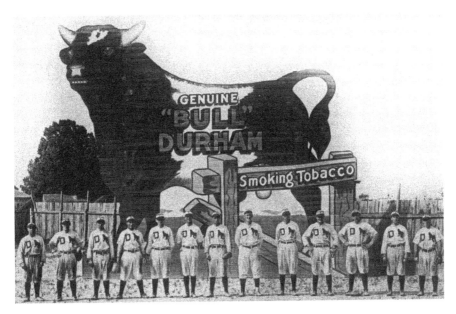

Durham Bulls team photo, 1913. *Courtesy Durham Bulls.*

which was then still located in the idyllic college town of Wake Forest, sent its Baptist Boys to face off with the Methodists of Trinity in Trinity's gymnasium—thought to have been the state's first college gym and built of lumber recycled from the grandstands of old Blackwell Park's racetrack. Word of this exhibition of "basket ball" did reach the front pages, though readers might have been excused if they overlooked it while reading about Charles Morton's arraignment on two counts of chicken thievery in the same day; "Chicken" Morton had already spent more than half the past ten years doing road work with the chain gang.

Athletic rivalries among the ivory-towered institutions of the state were already customary. When the University of North Carolina won a baseball game, the bullhorn on the Blackwell tobacco factory would sound. When Trinity won a game, the Duke factory whistle let out a war whoop. Some academics regarded manly sport as a harmless safety valve for the hormonal excess to which young male flesh is heir, though others snorted that games were a waste of scholars' attention and time and could be even gateway pastimes to "gambling and other immoralities...states of excitement subversive of habits of study." Trinity and the state university had begun a rivalry at football in the 1880s (who won the first game is a matter of dispute), but Trinity's serious and pious next president, John Carlisle Kilgo, banned that sport upon taking office in 1894.

Basketball, perhaps, seemed a more respectable diversion, at least enough to give it one old college try. Enough people in the area had heard of such a thing that about seventy spectators came to watch, from a balcony, and the game story reported that "every one seemed to enjoy the event very much." Attendance might have been greater, had not the Calhoun and Grady squads of Trinity Park School been at the same time locked in fierce debate over organizing labor. Wake Forest won the basketball game, 24 to 10; it also won a rematch at its own campus, but the Methodist five did achieve some success that first season, twice topping those debatable scholars from Trinity Park School.

The Fourth

When the Durham Traction Company laid out its electrical streetcar line, it, like most other firms engaged in that same business, recognized there were more avenues to profit from than just moving commuters to work and shoppers to stores and getting them back home again. Many doubled in real estate and building, snapping up country land that their lines stretched out

to reach and reselling it at suddenly appreciated (a.k.a. inflated) values or going ahead themselves to raise and sell homes in "streetcar subdivisions." In Durham, one of those sideline enterprises was an amusement park.

Early in 1902, the Traction Company bought twenty-seven acres located six-tenths of a mile beyond the town cemetery and announced it would there build a park "for the benefit of the people of Durham." On the eve of July 4 of that year, the park remained unfinished but nevertheless hosted a barbecue for the Improved Order of Red Men. Even so exclusive an affair required extra cars to serve the crowd, and an even bigger group was on hand for the official grand opening two weeks later. After all, recreational offerings around growing Durham were not too many, much less very varied, and this brand-new Lakewood Park boasted a merry-go-round, a roller coaster, a pavilion for dancing and, above it all, strings of colored electrical lights. It even had a bathing pond, down at the property's low end.

Well, the Traction investors had themselves a hit. Since, by this time, respectable people in North Carolina could observe the Yankee Independence Day without feeling grandpa turning in his grave, by 1904 Lakewood Park was hosting a "Glorious Fourth," going head-to-head with a picnic out at

Merry-go-round at Lakewood Park. Advertised as the "Coney Island of the South," the park operated from 1901 through the summer of 1936. *Courtesy Lakewood Park Community Association.*

The crest of Lakewood Park's roller coaster gave a view of the streetcar-suburb neighborhood that developed in the early 1900s. *Courtesy Lakewood Park Community Association.*

Redwood on the Seaboard branch just short of the county line. Lakewood management promised something "elaborate," including a barbecue and Brunswick stew supper provided by the Sheltering Circle of the King's Daughters as a fundraiser for their planned Old Woman's Home, and a splendid display of fireworks.

In another ten years, the park had added a roller-skating rink, orchestra concerts, bowling, vaudeville shows and a Natatorium with ever-freshened water. In the Roaring Twenties, Independence Day brought horses and a high-dive platform—local patrons could win prizes if they dared to get aboard, and two couples even celebrated their nuptials on high before sixteen thousand guests. Clarence Gainey and Janie Gentry and Archie Garrett and Bertha Campell took their vows upon the platform and entered holy matrimony with a splash.

Yet times went by and tastes changed, and so did management, and even though by 1932 its owners advertised Lakewood as a Southern Coney Island, the park's Fourth of July was utterly upstaged by an air parade and bomb-dropping contest at the East Durham Airport. After the 1936 season, Lakewood Park closed for good, and Independence Day was left to do the best it could on merits of its own.

The Air Bird

It was also in North Carolina, far to the east at Kitty Hawk, that those Ohio boys with the Wright stuff got off the ground in December 1903 and set adventure on a whole new dimension. A *Durham Recorder* jokester wrote, "Most any adventurous boy would prefer to be Wright than president," and twenty-five-year-old Jimmy Umstead must have thought he saw the future when, on May 3, 1911, an aeroplane came to our town for the very first time.

Invited by the Merchants Association to show his stuff above the baseball park in East Durham, barnstormer Lincoln Beachy put on a show of "dipping, circling, soaring into the ethereal blue" while "rivaling the speed of the swiftest bird." Overall, the turnout disappointed the merchants, but Umstead got "the air in his mind" and, just a few weeks later, left his home on Holloway Street and went off to investigate the state of aviation. That's what he said he was doing. Most of those he told about it thought he must be putting them on, but by Independence Day he was back as proprietor of Umstead Aviation Inc.

Umstead had incorporated to build, show and sell airplanes, but he had the further inspiration for an "airplane-mobile" that could soar into the sky and, if encountering bad weather or other difficulty, come down to earth, fold its wings and proceed along the ground—or start out as a ground car and take to the air when the road got as bad as North Carolina roads inevitably would get. To get his business up and soaring, though, he bought a seventy-five-horsepower Curtiss biplane, hired pilot H.E. Callahan and, as fall approached, hit the county fair circuit.

The circuit led Umstead Aviation to the great Midwest, where the fields were flat and wide and there weren't so many fences and rubbernecking loafers to get in the way of takeoffs and landings. The company did its first business selling rides and showing off at the Home Comers and New Comers Celebration at Henryville, Kentucky. Through the season, they went town to town, disassembling their plane after each show and shipping it to the next by train. Word spread: "Columbus [Ind.] is to have a real, live aeroplane here next week!" Two pilots fell to their deaths during a Chicago air show that Umstead and Callahan attended, but, as the hometown *Herald* affirmed, "Mr. Umstead does not have a yellow streak and so did not become discouraged."

Until one fateful day at the West Alabama Fair, that is. It was December 5, and Umstead and Callahan had one of their biggest crowds ever. Umstead even gave a speech before Callahan climbed aboard, revved the engine,

lifted off the earth and pitched into a nosedive. The crowd was speechless, but only for a moment, and then they rushed the wreckage for souvenirs.

It was not the climax he had dreamed of, but Air Bird had had enough. He folded what was left of his wings and went back to the nest by ground transport. "I didn't feel like embarrassing my father," he said years later, but he yet proved he was a man of indomitable spirit—making a fortune in beach real estate during the '20s and then successfully campaigning for the repeal of Prohibition, having, perhaps, decided there is more than one way to get high.

THE PARK

Our town, at least the older, inner sections, is blessed with many trees and parks. Look upon us from on high, the place looks like a forest. Trees have always been important in our town, a sentiment perhaps dating from the very early time when the old ridge and cleared farmland around it were known as the hottest place this side of his Satanic Majesty's realm.

In fact, the nature of our town's politics changed dramatically when, in 1972, some residents in an older neighborhood were wakened one morning by the sound of chainsaws and discovered the oaks that graced and shaded their quiet streets were coming down by order from city hall, to make way for a new thoroughfare connecting the central business district with the suburbs to the west. That was the first these regular citizens had heard about any such thing, and they talked, organized and hired a lawyer and marched on the city council to demand the trees be spared. It is tempting to imagine torches and pitchforks in their hands. And it worked. Nowadays, if you want to cut down a public tree, you better plant another one in its place, and as for mass grading—look out, is all I can say. Those neighbors stayed together and became a formal association, and now our town's Inter Neighborhood Council packs some punch. "Neighborhoods" are right up there with watching out for the taxpayers' money and solving the image problem when it comes election time.

In 1937, a street was even split in two to avoid a tree. The city was extending Markham Avenue from Watts Street to Buchanan, but a two-hundred-year-old white oak, twenty-two feet in circumference, stood nobly smack-dab in the way. To accommodate the tree, the road crew bowed the right of way outward and left an island of earth, a hundred feet long and twenty-four across, in between the two lanes of traffic. They even installed an underground watering system and laid the gutters such that public works

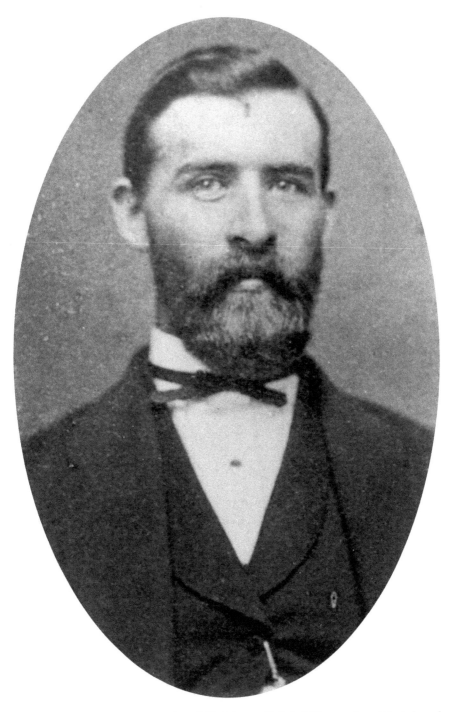

Brodie Leonidas Duke was the eldest of Washington Duke's children and contributed much to Durham's character. *Courtesy Duke Homestead State Historic Site.*

director H.W. Keuffner swore that not even a drunk could run a car into the tree. Sadly, old age caught up with the oak and it had to come down nine years later, but its island remains in case it's needed again or somebody downtown figures it's time to rebuild the street.

As for our town's parks, most of the older ones came thanks to John Sprunt Hill, the golf-playing banker from Tammany Hall, who accumulated a good bit of land one way and another and donated a lot of it for the public's pleasure. One of our sylvan landmarks, though, came by way of a different benefactor: Brodie Duke, who in the late nineteenth and early twentieth centuries bought up a swath of real estate that curved around the western and northern sides of town.

Brodie was Washington Duke's oldest boy and is often referred to as the family's black sheep. Not that he was by any means a bad fellow, but he did have three weaknesses: women, liquor and commodities futures. He was on and off the bottle most of his life, on it once to the point that, in a reorganization of the Dukes' tobacco company, Brodie was exempted from putting up any capital but had to cease from embarrassing the firm any more with how he carried on when drunk.

He became a silent partner in the business and may have held a grudge about it, especially if he felt his place in the family and its firm was being supplanted by George Washington Watts, whom the Dukes brought down from Baltimore to handle the financial operations. If so, it might explain why, when he laid out the streets in his holdings, he gave them names such that a map read east to west would say "Washington, Duke, Hated, Watts." The family probably gave Brodie a talking-to, for a street was renamed "Gregson," in honor of the Dukes' preacher.

Brodie was married four times, made fortunes and went broke, but he ended his life with a young bride, a mansion where the old Carr Junior High building stands on Morgan Street (the low athletic field behind the school was the bottom of Brodie's fishpond) and a history of charitable bequests of land, including a tract on the Roxboro road where he let folks graze their cattle and strip mine for coal, thus leaving the land cut with deep and steep ravines. When he died in 1919, Brodie left that land to the city, which did nothing for it until the Depression, when the New Deal made money available for building nice things like parks.

City hall wanted to develop Duke Park with tennis courts, an amphitheatre and swimming pool, but, by the mid-'30s, a fashionable Duke Park neighborhood had grown up around Brodie's bequest. A lawyer named Basil Watkins, who had just moved in, started a grass-roots drive to put an end to any such thing as a public park. He and his fellow travelers claimed a

park would attract "an influx of undesirable elements" who would make the park loud and crowded and generally obnoxious to those who had come to the neighborhood seeking peace and quiet among their own kind. Watkins did get seventy-five names on a petition and railed to the city council about sacrificing trees for the sake of swimming, the cost to taxpayers of maintaining a park and picking up after littering undesirables.

Despite the "verbal fireworks" reported, the council did what it wanted and got its park. The pool became the scene of an annual water show and provided summer refreshment until 1993, when the pool developed an irreparable leak into the underground stream right under it. The city filled in the pool and planted grass there. Some of it grew.

THE MYSTERIOUS BOTTOM

There never was any monkey in Monkey Bottom. At least, that was the contention of the late Louis Cole, who ought to know since he was born in that part of our town, the West Durham village around the Erwin cotton mill, in 1919, and grew up there and delivered groceries as a boy. So he knew every bit of the place. But he didn't know why that name was applied to and stuck to the lowest point in West Durham, right off Erwin Road by the railroad trestle.

Sure, there are stories about where it got the name. One says the name was a racial slur for the bottom's residents. Another says there used to be a little zoo down there in a village park. Another says some monkeys got loose from a circus once and made themselves at home in the low ground. Circus parades did process through West Durham in times gone by, marching from the railroad to the fairgrounds out on the Hillsborough road. But Cole always insisted there never were any monkeys in residence.

Legends and names have it all over facts, though. A schoolchild from West Durham was heard to misidentify her Southside School as Monkey Bottom School, and when flower children of the '60s occupied an old mansion up the hill, they dubbed it "Monkey Top."

Monkey Bottom is very close to where old Pinhook used to be, so maybe the "monkey" part is as in "monkey business." In any case, another part of the legend has it that the president of Erwin Mills said he'd reward anyone generously who could tell him where the name came from. He never had to pay up.

THE GOOFY STUFF

Everybody knows about the flying saucer crashing in Roswell, New Mexico, in June 1947. E.T. didn't make it to our town that summer, nor for several more summers, in fact, but the season was not without its strangeness.

Otis M. Cates filed for divorce from his wife, Alveena, the two having been separated since 1932. A wandering salesman came into city hall and asked for a job as a detective after making a noise like a klaxon horn. He didn't get the job. Maybe he could have got to the bottom of the Goofer Dust, though.

One morning in August of that year, one George Williams of the St. Theresa neighborhood below the tracks was brought before the bar of justice for, it was held, threatening his neighbor with bodily harm for hexing his, Williams's, property. The alleged hexer, Jesse Jones, testified that the alleged hexee, Williams, had accused the said Jones of brandishing a meat knife at him and rooting in his yard. Jones said he didn't know anything about rooting and that Williams, the alleged hexee, had, some months previous, accused Jones of throwing an egg at his porch and threatened him with bodily harm.

Taking the stand, Williams's wife said that almost every morning, very early, she had seen Jones looking about as if to determine whether anyone was watching and, when he thought the coast was clear, sneaking into the Williams's yard to spread dust that looked kind of like gunpowder. She had not been affected, but her husband said this dust had caused him pain in his feet and legs so bad he couldn't walk anywhere close to his woodpile or garage. His agony was so great he had even paid $200 for the services of a "de-hexing doctor" from another state.

The particular incident precipitating the case developed when Williams caught Jones dusting near his gate. When the two men ran into each other again, later, Jones reached into his pocket. Williams thought he was going for a knife and snatched up a stick for self-defense. Mrs. Williams stepped in between them and Jones went to file charges for assault with a deadly weapon. The judge ruled that Williams was innocent and went on to deal with the more routine speeders, batterers and drunks on the morning's docket.

It was almost five years before the aliens arrived.

In the early evening of Monday, January 25, 1954, law student Harold Bernard was crossing a street and noticed white vapor in the sky. A moment later, he saw a huge spherical thing, green with a hint of red, moving fast. About the same time, two commercial pilots flying southeast of Durham spotted something flying off to the north, describing an arc, too slow and

Statue of James Buchanan "Buck" Duke in front of the university chapel, dressed for Halloween 1973; almost twenty years earlier, flying saucers had called on Durham.

bright to be a meteor. F.W. Fletcher of the Bethesda community in eastern Durham turned to a man standing next to him and said he'd seen either a flying saucer or the strangest airplane ever; whatever it was, it was gone by the time the other man looked up.

Flying saucers or, if you insist, UFOs, had been a part of popular culture since June 1947, when a private pilot named Kenneth Arnold reported nine "disc-like" objects flying near Mount Ranier, in Washington (state), and magazine publisher Ray Palmer got hold of the story and made strange things in the sky a national sensation, with reports coming left and right for year after year as pulp journals and Hollywood made the best of a good thing while it lasted.

Whatever it was buzzing our town in the evening may have come back later, because Mrs. W.H. Perkins, who was sitting up late writing a letter to her husband in Korea, looked up about a quarter to 1:00 a.m. and saw an object she described as "odd shaped" and half the size of a full moon. It was shining through her window and it scared her. When she cut off her lamp, the thing started flashing red sparks and moving away, then flashed really bright and was gone. Mrs. Perkins telephoned a neighbor for comfort. The neighbor told her she was nuts. Then she got her morning paper and saw she hadn't been the only one.

Two nights later, another student saw a green light flying high and fast, but that was it for the saucers' interest in our town. At least, if they stayed around, they stayed out of sight. But a few nights later, there were several strange occurrences: Dr. Waldo Boone's hubcaps vanished while his Buick rested in his closed garage, Page-King Tire Company was relieved of electronic apparatus, a battery and some three-cent stamps, while Bailey's Service Station was robbed of its condom dispenser. Had E.T. stopped in for biological research and gone scavenging for components to call home? If the hubcaps didn't serve as signal dishes or the battery didn't give enough juice, he could have planned to write—since, in 1954, a three-cent stamp would go a long way.

THE DROWNED VILLAGE

What remains of Orange Factory is just the name. At least, that's all the eye can see unless you don a scuba mask and swim down through murky waters to the bottom of the Little River Reservoir.

For many years it was a real place, high and dry. Had some importance, even—Orange Factory Road, after all, does carry on the name. There was

a factory there, and a village, and the memory even spawned a preservation committee. Too little, too late.

By the 1960s, it was clear that the city of Durham was going to need more water. Lake Michie, the reservoir that had served since the 1930s, wasn't going to be able to handle the projected growth and, after eco-opposition foiled early plans to flood the Eno for a second lake, the engineers looked one river north. In 1983, Orange Factory's last eight households were moved out of the way of progress.

There had been dozens of households in years before.

Orange Factory began as, naturally, a factory—a cotton mill, prefiguring by decades the industry that would vie with tobacco for top spot in the town a few miles south along the railroad. In 1852, John Huske Webb and John C. Douglas formed a partnership to manufacture cloth and thread. The name was a natural choice, since theirs was the first factory in Orange County aside from John McMannen's smut-machine works a little way upriver. McMannen's operation, though, was hardly in a class with what Webb and Douglas wrought—ninety-four feet from footing to rooftop, powered both by steam and liquid water.

The partners also built a gristmill, houses for their mill hands, a boardinghouse, a store, a school and a church. By 1860, Orange Factory

Orange Factory wove cotton cloth on the Little River and stimulated a village to grow. Its site is now at the bottom of a reservoir. *Courtesy Ed Clayton.*

could turn out 140,000 pounds of cotton yarn, and when the state of North Carolina went Confederate, it contracted with Webb and Douglas to supply cloth for uniforms. Maybe due to the reversal of Confederate fortunes, maybe for other reasons, the founders sold out in 1864 to William Willard, a gentleman from Massachusetts, of all alien places, who had moved south for his health.

Willard reorganized as the Willard Manufacturing Company and diversified into making rope, hosiery cloth and bags. When the Lynchburg & Durham Railroad was built nearby, it named its station Willardville—you'll still see the name on county maps, as well as Willard's Station Road. There's no trace left of any station, and the tracks are abandoned and overgrown, but humps in the pavement still mark where the grade crossings were. After Willard died in 1898, his assistant, Albert Cox, and a James Mason bought the business and reorganized it again, this time as the Little River Manufacturing Company. Cox is remembered as the main benefactor of Riverview United Methodist Church, originally Orange Factory Methodist, which perches on a hill that overlooked the village and now overlooks the reservoir. The company was sold again in 1916, becoming Laura Cotton Mill, and continued operations until, obsolete and worn out, the plant shut down for good in 1938.

The village carried on, though. It lost population as the years went by, people drifting off to bigger places with more opportunity. In its late years, residents looked back on times when menfolk made whiskey against the law, women went swimming in old dresses because they didn't have money for bathing suits and people walked up the hill to Sunday school and got baptized in the river. Facing the prospect of being flooded out in 1980, Effie Castle told a reporter, "We're the happiest po' folks in the world, if they'd just leave us alone."

But they didn't, and now waters bound for mixing the drinks and washing the cars of Durham lie over the foundations of an old hometown. Looking down from the hilltop churchyard feels fitting, for up there elegy is what it's all about.

THE LAST AND FIRST DAY

Spring mornings, in the rolling-hill and farm-pond country north of town, start out dew-damp and sparkly. Light haze dawdles in the woods like the children of collective imagination, if not really memory, stalling all the way to school. The way time itself drags at that age as it gets close to the last day.

Woods surround long-abandoned South Lowell School in the hilly region of northern Durham County.

The way it would have dragged once, for all the children like you used to be, who were educated at South Lowell School.

The children are long gone, the school closed these seventy years or more, but the schoolhouse is still there, even though you may have to look hard for it in the springtime when the leaves have budded out and the vines resumed their growing. It's up in the woods, off South Lowell Road—another commemorative name, recalling the ambition the Reverend John McMannen had for the community growing around his smut-machine manufactory—in the prettiest part of Durham County.

A window made of ornate teardrop-shaped panes gapes blankly from a second-story gable that is centered over where twin doors once hung. The open entrance gives view clear through the building to a big oak tree, under which the kids once played games like "Andy Over" and "Goose and the Gall" under the steady gaze of Miss Beulah Wilson Breedlove. At the end of term, she would lead the children in a show for their families. They would decorate the school with greenery from the woods, and decorate a wagon and all go to ride.

Graffiti at the back door of South Lowell School, with a view to the woods on the building's far side.

Modern Times

The school years' ends still bring their ceremonies, but they also still bring beginnings, and the last days of school can get lost, unnoticed, in the giddiness of summer's edge—"the first real time of freedom and living," as Ray Bradbury wrote at the beginning of his *Dandelion Wine*. Old school years get left behind in the rush to the imagined times ahead, fantasies, and may only be appreciated in bits and pieces reordered and refined for the use of futures unthinkable at the time they were fresh and sparkly as those dawdling dewy mornings, last and first at the same time.

THE PARADE

In town, in December, they have a "holiday" to-do. In Bahama, they have a Christmas parade. (Not to be outdone, its rival village of Rougemont has a parade for Easter.) The way it came about is that one Christmas back in the 1970s, Howard Trickey got together with a mule, a wagon and a jar of white whiskey.

That's his story, anyway. The local Ruritans sponsor it now, and white whiskey is not encouraged, but a mule and wagon would be OK.

What happened was that Christmas Howard and the wife of his buddy, Mike Terry, went in cahoots to get Mike a wagon for his present, along with a mule to provide its motor power. Mike had wanted one for the longest time. Christmas morning, Mike was duly appreciative, but some assembly was required. He called Howard to come show him how to put mule and wagon together. Once that was accomplished, the two men and a jar of Christmas spirits took the mule and wagon out for a spin.

They stopped by the village store to show off, and someone said they ought to have a parade.

Seemed like a good idea at the time. When next Christmas rolled around and it still seemed like a good idea, they did it. Santa Claus rode in a borrowed sleigh behind a white horse.

Now the community's been doing it ever since. It got bigger and bigger, and folks from all around started putting it on the calendar. Homefolks that have moved away come back. There are school bands, scouts, sheriff's cars, fire trucks, a few floats and a local celebrity or two. Just a good ol' country kind of parade. Just about everybody takes part, and everybody else comes to watch.

They don't make many of 'em any more.

THE FESTIVAL

Our town has a festival around the Fourth of July now. It's not an "ole-fashion Fourth," though there is ice cream and watermelon, and the fireworks are still lit off downtown at the ballpark. But halfway out toward the country, at West Point on the Eno city park, the Association for the Preservation of the Eno River Valley holds a shindig over several days to extol the virtues of going green, with musical accompaniment and cold drinks (non-alcoholic only, we're on city property here) to help beat what invariably feels like the hottest weather all year.

It's a pretty correct affair, with compost demonstrations and a minimal carbon footprint. There are canoes to take for a drift on the stream, an old mill gristing its grist, booths for worthy causes and music from the old times played by real folks in Birkenstocks—even if some of the music is electrified now, a concession to the times that bothered some purists for a while. All in all, as paeans to the simple life of yore go, it's pretty city-slick and hip, but that befits the festival's own roots and raisin'.

Festival for the Eno started out as a fill-in for Joe College Weekend. It came about like this:

Joe College was for years Duke University's annual "spring fling" debauchery, held a few weeks after undergraduates got back from spring breaks at Myrtle Beach and Fort Lauderdale. During the late '60s, though, when everything in college went relevant, the accustomed celebration fell somewhat out of favor and by 1974 had pretty well fizzled out.

Now, an undergraduate from Texas named George Holt had spent a summer in Washington, D.C., and became enthralled by the Smithsonian's annual Festival of American Folklife. A neighbor in the dormitory back at school—Nick Tennyson, later our town's mayor and head of the home-builders' association—engaged Holt in helping come up with a model for doing something special in the spring. Holt contrived a folk festival of Duke's own, showcasing North Carolina folklife like snake-oil pitchmen, moonshine making and cows and sheep out on the quad around James B. Duke's statue and in front of the chapel where, as it turned out, there was a wedding going on at the same time as the folklife. The pigpen went right under the office window of the university president.

It actually worked well enough that Holt staged it again the next year. The year after that, by which time he was an old grad, happened to be the bicentennial of U.S. independence, and all over the country every patriotic city, town and country crossroads was doing something for the occasion. An older fellow alumnus, Bob Chapman, had been engaged to do the same for

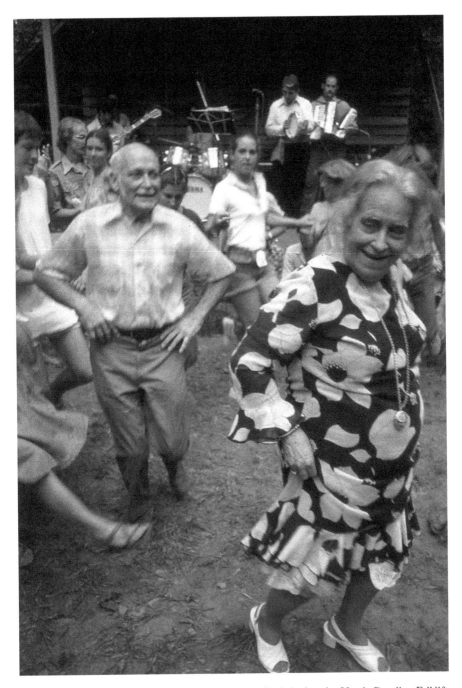

Sophie Galifianakis kicks up her heels at West Point Park during the North Carolina Folklife Festival, July 1978.

Durham. Having seen what Holt had done, and finding Holt still hanging around, Chapman invited him to do what he had done on campus, only in a much bigger way.

Holt set to it, shooting for "Smithsonian-level integrity." Really folky. No Peter, Paul and Mary sounds, no plastic crafts from China. Only practitioners of tradition handed down through Ma and Pa and Great-uncle Hezekiah. In the meantime, the city was rushing to get a park in shape on the riverside land it had originally bought in expectation of flooding it for a reservoir. The Liggett Group (previously Liggett & Myers Tobacco) folks, good corporate citizens, signed a blank purchase order for whatever anybody needed. Holt's uncle happened to be chairman of the House Armed Services Committee, so the army donated a walkie-talkie system. Everything went off fine: seventy-five thousand people showed up over the three-day weekend, receipts were so heavy that the bank's night-deposit drawer would hardly shut, and it was all so much fun that, two years later, Holt did it all over again with the backing of the State of North Carolina.

This caught the notice of the Eno River Association, a group formed in 1966 by the indefatigable Margaret Nygard to protect the thirty-mile stream from damming and development. In 1980, the association took up the festival idea and has staged one every Independence Day since, raising money to buy land for the Eno River State Park. It's been thoroughly successful, a signature event among the claims to fame our town's convention and visitors bureau boasts of. Honestly, it's one of the elements that goes into making our town our town. "See you at the Eno" is our own shorthand conveying time as well as place—Fourth of July and a particular spot out by the riverside.

It just goes to show how things have changed. Back in the '70s and '80s, "folk" sounded kind of subversive. Hadn't that banjo-picking Seeger fella been some kind of a Communist? For folks around here, the very word raised mental pictures of peaceniks, funny cigarettes and un-American activities. And "festival"? Was that anything like those "fiestas" down in Mexico?

Yes, for some, a folklife festival was alternative reality, but not alternative enough for all. The Festival for the Eno spun off an alternative counterpart, the Forklift Festival. It was only held for a while, hasn't been for a gazillion years or so, it seems, but while it was going it was truly memorable, or would have been except that it was the kind of affair that, if you were there, you wouldn't remember.

The Forklift Festival was an after-party party at an old plantation. In fact, the hipsters who rented the abandoned Lochmoor, former country place of tobacco man E.J. Parrish, called it "the Plantation" in ironic salute to what they thought of as Southern heritage. According to the *Durham Historic and*

Architectural Inventory, it was a "rambling two-story frame house" and "the most sophisticated farm complex within the city limits," though those who partied hearty behind the convenient woods screening the house from view considered it just a great big hangout for hippies. While the Eno Festival went on just down the Roxboro road, the Forklift set were reveling nonstop. After the volunteers and music makers did their respectable jobs and acts for the river's sake, they'd come over and join in. The name "forklift" came because there was one sitting long unclaimed in the yard.

So for a while, we had the Forklift, but as time went on the alternatives weren't so alternative and the flower children got MBAs. The hippies moved out, the owners had ideas about developing the Lochmoor property and the old house and its outbuildings have been torn down. The trees and weeds and creepers have grown back. They say the old Forklifters sometimes drift back there, commune with nature and their former souls, then get on back to work and raising their children to be upstanding and productive citizens.

That's kind of patriotic.

PART VI

SIC TRANSITS

THE DRIVER

Are you nervous?

"Yes."

Flat statement. Snapped out. Definitive. She really is. It's kind of nice for a change, a fifteen-year-old telling her old dad just how she really feels at the moment.

"Good," you say. She ought to be, and anyway, you are the authority figure here and she will actually acknowledge that. After all, you are about to start teaching her to drive. And you need any little reassurance you can give yourself.

First driving lesson. You're a father. You knew this day had to come, and you want it to come at the same time you wish it wouldn't ever. Like the first sleepover away from the house; first day of nursery school; first day she gets on the school bus and, what's more, manages to get home on it all by herself.

There are so many of them, firsts: first creep at the door with nose rings; first college visits; first prom; first trip overseas without parents; first broken heart.

You're still needed, though, and so here you are in a church parking lot on a weekday afternoon. Nobody else—preacher's gone, secretary's gone, no organist come to practice nor penitent to pray. A church parking lot is just right for that first go-round.

"This is your accelerator, that's the brake. Gearshift, speedometer, temperature gauge, fuel gauge. If the idiot light *ever* comes on, *stop!* Move the seat so you're comfortable. What can you see in the mirrors?"

"OK, turn the key. Forward, neutral, reverse, park. Pull the lever toward you, pull it down until you feel it fall into gear. You'll feel it, I promise. Now let's go."

Now, you've gone and done it. And so has she. The baby girl you fell in love with as soon as you picked her up the first time, who still scares you every time she goes to cross the street—she's in control of a ton or so of machinery that's in motion, burning gasoline. She lurches around the shrubbery and you realize you're getting older now. And so is she.

And she, unlike you, can feel it. Having gotten accustomed to the essential stasis of middle age, you forget how it is when constant change is the inescapable fact of life. Every fall, a new grade; every year, another inch or two; passions come and go through dolls to dogs to soccer to horses to boys to life's work, maybe. But it makes you think that, when you are in middle age, the changes will start again and every year, if not every month, will mean something doesn't work like it used to.

"Past the sanctuary, turn up the hill, speed up a little around the parish hall and now do it again. Press on the brake. Stop, look, left, right, left. OK, go on." She's not gripping the steering wheel so hard. She's getting it and soon it will seem as natural as talking on the telephone, without her realizing when it happened.

Like the minute she was already riding her bike, by herself, away from you. Like the minute she forgot she was scared of water and swam away toward someone she recognized across the pool. Because you gave the push and let go.

It's a cliché, but they don't stay little long. Playing dolls with grandmother, running after bunnies and ducks at the Museum of Life and Science's barnyard, winning the scholarship to college. Moments don't last long at all. Even if you take the car back over to go home, you know she needs you a little bit less than she did an hour ago. And that's the whole point of being a parent, even daddy to a little girl: to bring them up so they won't need you any more. You love them so much, you have to raise them so they'll leave you.

The Porch

So fast, the changes. Durham, we hardly knew ye. You blink once or twice as you're riding along some road that not that long ago was country and wham! You'll have missed the emergence of "neighborhoods." That's what they call subdivisions now, "neighborhoods," or, worse, "communities," as

if those were something you could whip right up with a dozer blade and a set of homeowners' association Thou-Shalt-Nots. There is just such a "community" right where D.L. Bishop used to go scoop up his fertilizer and, friends and neighbors, it's enough to put a tear in your beer.

Half a lifetime ago, in 1974, Friday evenings meant get-togethers on D.L. Bishop's front porch. D.L. lived out in what was the country then, so there wasn't anybody close enough to bother when the banjo got a little twangy and the singing got a little loud; when fiddlin' Dave McKnight, fresh off work in Raleigh, announced his arrival with a viola version of "Orange Blossom Special" and someone else had just enough tall Budweisers and broke out in "Wabash Cannonball."

Spring and summer, along about sundown, Ed and Natalie would roll up in their purple Capri, Johnny Carroll in his '64 Chevy, Phrog in his VW convertible. Patsy would go pick beans, the boys would fling around a football until the sky turned purple. By that time, somebody would have a fire going in the barbecue grill; Ed would pluck a note on his autoharp and John on his guitar; and D.L. would give up any pretense of managing things, pick up the banjo he had made with his own two hands in the hills of Tennessee and start picking the "Bragtown Blues."

D.L. Bishop on banjo and Ed Martin on autoharp make music by firelight at the old front porch, May 1974.

There was a sweet young couple who brought an old Methodist hymnal, and it was just amazing what grace it brought back to children of the '60s who thought they'd sworn off church forever. But in the firelight and under the stars—the sky actually went black enough you could see thousands—the night had mystical powers. Faces were warmly sidelit. One night someone's cousin showed up, a hard-living, red-haired woman whose ex-boyfriend had run his Camaro into her new boyfriend just to show how much he loved her. There was a couple who worked late and came out around midnight—they've been married more than thirty years now.

So it passes. We came from other places and have gone on. D.L. went to Nashville, and his oldest boy's grown and the younger one just about. Ed and Natalie went to Charlotte, and they haven't been heard from in a while. Johnny C. made a career in newspapers when such a thing could be done and is a grandfather now. Fiddlin' Dave' ran for the U.S. Senate, finished fifth of eight in the Democratic primary and plays music on the sidewalk these days. There is a church, of all things, where Patsy used to pick her beans, and the cow pasture out back where D.L. gathered cow patties for plant food metamorphosed into quarter-acre lots. Where we tossed the football, the trees that were just saplings have grown the size of defensive tackles. It hurts a little, to see the places we camped, caroused and courted turn into just more real estate.

Yep, we do hate to see the cow pastures going condo but that's not really the point. If we're really honest with ourselves, what we really hate to see is that now we are going gray.

THE BREEZE

Even now, if the air is just right, an odd breeze may bring back a trace of Tobacco Row.

It's kind of nice to think so, though the whiff you think you catch from the open doors of Liberty Warehouse could just be one of memory's tricks, or wishful thinking about the old days when tobacco was the heart and soul of Rigsbee Avenue and the auction houses were smack in the middle of town.

Come fall now, there are no piles of yellow-brown leaf, no farmers waiting with a patience positively surreal, no buyers picking their teeth from lunch at Green's Grill or the Little Acorn and no government graders scampering from pile to pile, marking and dealing out price cards with the dexterity of riverboat gamblers. No more auctioneers who would arrive in their Cadillacs to the sort of acclaim that rock stars get these days. No more *"Sold American!"*

Liberty Warehouse, 2000. When conditions favored, an aroma of golden leaf remained long after Durham's "Tobacco Row" markets closed in the 1980s. *Courtesy of the author.*

In seasons past, the air on Rigsbee Avenue would have been literally fragrant and figuratively electric. By mid-July, the price reports would be pouring in from the earlier-harvesting "belts" in Florida, Georgia and South Carolina. From late summer through fall, hundreds of farmers would haul millions of pounds of leaf into Durham to sell at a dozen or more warehouses. Market season was the time when money flowed. The newspapers proclaimed "Welcome Mr. Farmer" from the fronts of special sections full of ads for furniture, appliances, hardware, work clothes, Sunday-go-to-meeting clothes, tires, loans and everything else the farm folk had been working toward all year. Politicians would come to be noticed, lenders to find out how prices were holding up and shopkeepers to see how much merchandise they might expect to move. Outside, on the sidewalks, there would be a veritable carnival of snake-oil salesmen, card sharks, bootleggers, gypsy fortune tellers and black men playing the Durham Blues.

Durham's record year was 1947, when the warehouses sold fifty million pounds of tobacco. There were were Roycroft's 1 and 2, Liberty 1 and 2, Mangum 1 and 2, Star 1 and 2 and Star Brick in three blocks of Rigsbee, and Planter's around the corner on Chapel Hill Street. There were more than half a million square feet of sales floors, wide and open and skylighted

Tobacco Row in its glory years, when millions of dollars traded hands and auctioneers, snake oil salesmen and sidewalk music makers made market season a carnival.

The end of Tobacco Road, a dirt street in an east Durham industrial section. Durham's last tobacco sale was held nearby in 1987. *Courtesy of the author.*

so buyers could judge leaf color right. Durham's tobacco market ran 117 seasons. It ended in 1987, the same year that the American Tobacco Company left town. The last warehouse was not on Tobacco Row, but a couple of miles away in an industrial district at the edge of town, near the poignantly named dirt lane Tobacco Road.

Now, the old warehouse district is called "Durham Central Park." There is a farmers' market and public art, and a walking/cycling trail runs through. The Liberty is the only warehouse left on Rigsbee Avenue. Part of the building is now a sculpture studio and part a nonprofit that deals in scrap for art projects. On the worn wood auction floor you'll just see piled-up stuff. A developer owns the place. For years after the last tobacco was sold on that floor, in 1983, a painted sign just inside one of the truck-wide doors still read, "You're Always Welcome at Durham's Shopping Center," and above it hung a faded poster advertising Kool cigarettes. But there's little left to hint at what there was.

Except, once in a while, that aroma. A sweetish, heavy scent like that you meet in old small-town courthouses, evocative of cuspidors, dark wood, old varnish, old men, old times. If the air is just right, and you're in the mood, you might catch a whiff of time gone by. But just a whiff.

THE WHISTLE

Sometimes in the night, you can hear the sound of a train. Not the clackety-clack of steel on steel, nor the rumble and roar of displaced air and mighty engines—no, just a lonely moan in the distance that comes to the ear like a ghost.

Perhaps it is a spectral sound, for it may be heard miles as the crow flies from any corporeally operating railroad, actually best close to an abandoned spur of the Norfolk & Western track that once connected Durham with Willardville, Bahama, Rougemont, Roxboro and points farther north. In fact, eerie lights and sounds of unseen locomotives have been reported from around the line's old Hamlin Road crossing at Catsburg—the country-store crossroads so called for nearby resident "Cat" Belvin, who, as county sheriff, could move quiet as a feline, if not a ghost, when sneaking up on a moonshiner. But then, there's something ethereal about any railroad nowadays, isn't there? Particularly in a town midwived by them, whose disused tracks lead only to long ago.

Rusty rails are not too busy any more, but cinder and creosote fragrances linger among the weeds. The cotton mills and silk works

Morning fog adds a spectral aspect to abandoned railroad tracks. A railroad brought Durham into being, but that past has mostly passed away. *Courtesy of the author.*

that the railroads ran to meet are long gone from Durham's Station, and the tobacco business is only memory. But go down to the parking garage where Julian Carr Street ran by the American Tobacco factory turned mixed-use project. The street once ran through the town's only underpass there, affording safe access from the Bull plant to the business district. Later, the underpass was filled in and the street dead-ended into the railroad embankment, but if you look carefully you can find a flight of wood-beam steps leading up to a sloping terrace, where weathered crossties mark the route of a vanished sidetrack that ran not far from where the original Durham's Station stood.

Many people in Durham want to bring back the trains, but railroads will never be what they were, much less what they are in fond memory. Maybe, one day, they will be something else. In the meantime, miles of steel go to rust and weed instead of anywhere; cedars and pines grow up along ghost tracks; and eras go by like whistles from the dark.

THE REMINDER

The late George Pyne, architect, nature lover and raconteur, once described our town's old business district as a "medieval warren." The image is kind of romantic. It sounds jostling, busy, eternally varied, with surprises to be discovered around every odd corner, mystery down every cloistery alley and intrigues working from the cellars all through the maze. Also fitting, if you look at a map.

Locals who have been around some time still think of the district in terms of crowds, the congenial busyness of downtown as it was: rushing when the shifts changed at L&M and American Tobacco, cozily congested among the gritty confines of the CCB Building and the Jack Tar Hotel, the place to be on a Saturday, if for no other reason than to see what everybody else was up to.

Five decades on, the innermost district is in the process of urban renewing again to suit a new set of fashions in how a city ought to be and how it will best serve the residents of five decades hence—make that five quarters hence to allow for future shock—as well as the aesthetics of designers and the morality of eco-stewards right here and now. Then again, our town has been reinventing itself constantly since the end of World War II—when a coalition of open-minded Democrats, labor leaders and the already-powerful Durham Committee on the Affairs of Black People challenged the old guard of cigarette- and cloth-factory interests and broke politics in our town wide open. Our town remains in a condition of perpetual revolution, as Chairman Mao would say.

Keeps your attention, at least.

Back uptown, the old urban coziness has been given up in favor of vacant lots ("open space") where nobody's had use for land cleared under urban renewal, and on a weekend afternoon, even on a springish day that just demands one get outdoors, the sidewalks are a place to find solitude and peace, if a touch of wistfulness. You can't look at the monolithic Liggett & Myers plant, abandoned for cigarette manufacture and in transition to an apartment-office-retail complex called West Village, and not wish the old billboard up top was still advertising Chesterfields. It had personality. The Chicken in the Rough, which once waved its trademarked golf club from the Ivy Room wall overseeing the Do-Nut Dinette—it's gone, the brick left featureless on a corner building renovated and awaiting occupation.

Even most of the old signs that had survived have been cleared of their honest grime and gang logos and brightened to make the remodeled downtown look more like it's been remodeled. "Don't forget Doublemint

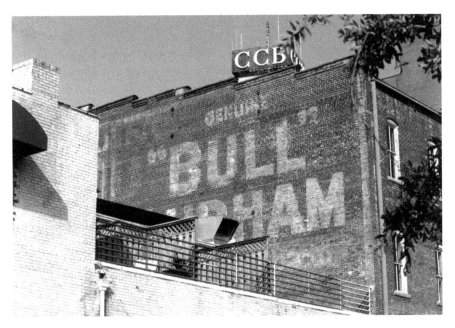

Painted Bull Durham sign evokes a golden-leaf era and is still visible in the old business district from the right vantage point. *Courtesy of the author.*

The post office on Chapel Hill Street opened in 1934. Its first sale of tobacco revenue stamps took in $304,000, enough to cover the building's cost of construction. *Courtesy of the author.*

Chewing Gum after every meal." "Drink Pepsi Cola at founts or in bottles." There are murals on some exposed walls, some of local relevance, and exposed walls that could use them, but there are some actual-factual relics of the district's former life remaining: the shields of Nash and Studebaker dealers, for example. The dealerships are gone, replaced by newer enterprises, but the signs remain.

Usually, if anyone in our town goes uptown it's for a reason: jury duty or trying to beat a parking ticket. A more leisurely approach, say, on foot, is more visually rewarding. While a glance one way brings to view a rearing hotel from the 1980s in its then-oh-so-hip lavender glory, a glance another way finds a gritty old newspaper office pretty much like it was the day they opened the new post office and paid for it in the first hour's sale of tobacco-revenue stamps. There's a sense of elegiac irony to standing on the site of Dr. Bartlett Durham's home and gazing upon the Lucky Strike smokestack, freshly painted in the abandoned factory's remaking as a ritzy office park and apartment complex, complete with new billboards for Bull Durham on W.T. Blackwell's building from 1874.

But if you get at just the right point on Chapel Hill Street, with the towers of N.C. Mutual and the police department looming to one side and the bus station office that once was a college that once was an A&P to the other—raise your eyes toward downtown across the railroad and you may discover a sign that has been there these years, risen high upon an art-deco office building in the east:

"Genuine 'Bull' Durham."

Our town, the once and future.

THE TIME TRAVELERS

A recollection: There was that thick, heavy smell of wood smoke that old kitchens have, soaked into their walls and floor, too set in and strong for even a fresh October breeze through an open door to lighten. The breeze could, though, swirl around and blend the aromas of smoke and frying chicken and boiling greens and the earth and woods outside, and it was welcoming. Like home. Sort of like Marcel Proust's madeleine, but touching something not so personal or particular, some deeper sense of comfort that comes with one's very genes. It was late afternoon, a red sun lay over a tree line one hundred yards away, and deepening blue shadows stretched long from reddened trees across the stripped tobacco patch and kitchen garden.

It was October 29, 1870.

Not really, but it almost could have been. In fact, it was October 29, 1983, a Saturday when I, my wife and our infant daughter had been invited for supper in the past.

Our host was Rob Worrell, who at the time was assistant manager of the Duke Homestead State Historic Site, on Duke Homestead Road just north of Interstate 85. When we came in, he was standing over a smoking woodstove, baking cornbread. It was well after hours at the site, the gate closed, and we had driven in the back way and parked some distance from the old farmhouse that Washington Duke built for his second bride, Artelia Roney, in 1852, and walked in along the remnant of the original road—leaving the present day behind. The homestead was well restored. We could look around a full 360 degrees and see no sign of the twentieth century.

Nowadays, "living history" is common practice at historic sites all over, but in 1983 it was a novel idea at places outside of Williamsburg and Sturbridge Village. Worrell, though, had made a habit of putting on the past. Every so often he would put on an 1870s costume, leave modern convenience (except for toilet paper—he did cheat just that much) behind and spend a weekend living like the people it was his business to tell visitors about. It frustrated him to know what he was talking about only from reading about it, and so he

Duke Homestead, about 1895. Washington Duke is walking toward the camera along the fenced lane. *Courtesy Duke Homestead State Historic Site.*

would take two days and grind his own coffee by hand, roll his own cigarettes, dry his face with a feed sack and brush his teeth with a blackgum twig. "If a visitor comes in and sees clothes hanging on a nail and shoes under the bed," he said, "the smell of woodsmoke from breakfast still hanging inside, sees clothes soaking on porch and potato peels in the yard and chickens pecking at them, it gives a better impression of what it looked like, smells like."

Settling around the table, on the grownups' part there was self-consciousness that this all was a put-on. The baby could not have cared less. But the mood developed, for after all it was fall, season of nostalgia, as the world, briefly pretty as it can be, is nonetheless closing down. Shadows flowed into the kitchen, or was it the light flowing out? And Worrell's experiment was no abstract endeavor. He was cooking according to his great-grandmother's recipes—the kind that start out instructing that to fry a chicken one first "kill and scald" one. As a boy, he said, he'd spent a lot of time at the old family farm, killed many a chicken and slept under a feather tick. As the shadows rose, the oil lamps came out and we ate by their soft, red light, which made faces warm and left murky points of shadow behind a trunk or under a chair. The food was hearty, if oddly lacking in the salt made customary in years to come, warmed down with a little homemade scuppernong wine. Our daughter, fed and changed, turned fretful in her mother's lap.

"Try that," Worrell said, motioning to an antique cradle on the hearth. We did, and in a few minutes, Elizabeth was asleep, gently rocking in her machine-made blankets and the handmade bed that was just her size. Satisfied, we sat and talked like people did back then while the world outside went dark.

"Were you a history major?" I asked.

"Classical archaeology," said Worrell. "You dig a Greek temple or a tobacco barn, the techniques are all the same."

The evening went on, assuming the tones (in memory, at least) of an old photograph—that same snug tint as the Irish whiskey Worrell presently brought out, that same mellow, warming glow made of companionship and good sound walls between you and whatever lies in the dark and chill beyond them. Getting into the spirit, we started swapping scary stories—visiting New York City, for one, and the eerie glows and half-seen reflections that come upon one in an old house, alone.

But it did grow late, eyelids got heavy and tomorrow was on the way. Leaving wife and sleeping baby in the security of home and hearth—albeit with lingering ghosts from the stories we had told—Worrell and I went for the car, he lighting the way with a flickering lantern for a couple hundred yards across rugged, bumpy ground. It was a dark night, really, really dark

behind the screening trees, a dark you don't see much anymore. And quiet, with just the scuttling of shoe leather on pebbly ground. The engine, when it started, was unearthly, the glaring headlights obscene. We drove back over the laborious ground we had just walked, covering it in seconds.

The wife had not liked being left alone with the spirits, but then they were dispelled by the gnashing of gears and bouncing of springs as we drove up the lane made into a tunnel by the overhanging trees. And then! We burst out onto a paved road and into a riot of lights and noise and confusion—back to 1983. It was a shock.

Because we had been somewhere else. There was no fooling the jangled nerves, the eyes that could not focus, the whole explosion of that moment when we burst back into our own place and time. Because we had been gone somewhere. Somewhere very else. You can't bring back what's past, but just in a while, once in a while, if things are done just right, you can come pretty close.

EPILOGUE

A Sense of Place

They're *still* arguing about that stupid flag?!!

The fifteen-year-old was just home from two weeks at summer camp.

Yes, they were still arguing about the flag. This particular flap had been going on not quite a year, ever since the city cited a restaurant for flying a six-hundred-square-foot U.S. flag on a pole that was seventy feet tall. Both numbers violated the sign ordinance.

The matter quickly became the subject of vigorous city council debate; after three more businesses were similarly cited, the council voted to keep the ordinance as it was. That kept the flags breaking the law and in the public mind, and letters-to-the-editor columns continued through the fall election, when candidates of all persuasions covered their symbolic chests if not their rear ends with patriotism. Meanwhile, another sign affront burst onto the civic scene: a plastic cow that had, since time immemorial, stood atop a suburban convenience store—commonly known, of course, as the "Cow Store." The city council took up this issue, as well. By then, it was November 1997. The flag citation had been issued in August.

Debate carried on into the new year. The city created a subcommittee to talk about the ordinance in February. In May, with one city councilman's encouragement, the restaurant where the flag flap began defied the law and raised its banner again. It got fined $200 and the manager lowered the flag again. In June, the council voted against a code revision devised by the subcommittee it had created in February that would have made exception for the U.S. flag but did accept an amendment that let the plastic cow remain in place as a historic local landmark. The convenience shop owner, however, was notified that his sign was three feet too high.

This plastic cow stood atop a convenience store for decades, then in 1997 it was threatened by the city's sign ordinance. The cow came out the victor, deemed a historic landmark. *Courtesy of the author.*

A Sense of Place

On Flag Day, June 14, the restaurant defied the law again and got a fine of $300. Then the Veterans of Foreign Wars, American Legion, Military Order of the Purple Heart and Marine Corps League let the city know they were going to raise an illegal flag of their own as a sign of solidarity (the ordinance had no language regarding solidarity), and so they could sue the city for free-speech infringement if the authorities wrote them a ticket. The city demanded $25; the veterans made a federal case of it. Soon somebody found that the flagpole atop the city's tallest building and most of those on public school grounds were too big, too.

This was about the time the fifteen-year-old got home from camp.

A year after the whole mess had begun, the city council took a third vote on the sign ordinance and changed its mind, raising the size limit to 260 square feet and the legal height of flagpoles to 70 feet. While the flag flap and cow controversy had been going on, the city council had also voted itself a 37 percent pay raise. After some public objection, they cut the raise to 9 percent, but it was not enough to placate a public fed up with its elected leaders' dithering over flags and cows while the drug dealing went on unnoticed, the potholes remained unpatched and the city's image suffered.

Now, the reader should understand that this loony episode was not unique. High-tech trash trucks, the town dump, city hall's golden parachutes, sensitivity surveys, small-business loans to nonexistent companies, slumlords in high places—all that and more have given Durham ammunition with which to shoot itself in the foot, in its official capacity. Back in the '80s, a worthy citizen proposed that the city paint some civic-pride message on a rusty water tower that stood beside the freeway from the airport. Elected public servants took up the cause. They debated for weeks. What message? "Welcome to Durham"? Perhaps "Welcome to Durham, N.C."? The public works department agreed to paint something up there, but then there was the color scheme to decide. Duke University's blue and white? North Carolina Central University's maroon and gray? The all-American red, white and blue? It's a small wonder that the Durham Bulls' color scheme of royal blue and University of Texas burnt orange wasn't tossed into the mix as well. Or maybe it was..

After two months' deliberation, the city worthies settled on a blue "Welcome to Durham" in the typeface New Gothic Bold. But then the agreement came undone. Some citizens were annoyed that the message did not mention "City of Medicine," the then-current image-boosting slogan. One council member declared this was all "mindless boosterism" and another declared, "Welcome to Mayberry." Yet another called for further study. The council took another vote and agreed to forget about it. It was eleven more rusty years before the water tower finally got a coat of paint—plain white.

The Slogan Sign by day. After the sign was put out of order by a storm, the chamber of commerce decided it was not worth the cost of repair. *Courtesy Durham Public Library.*

But in Durham, citizens will only stand for so much. In 1998, after the flag, the cow, the raise and a number of other embarrassments that had festered for longer in the community's mind, the peasants rose up and petitioned to whack the city council from thirteen members to seven, figuring that six fewer mouths would emit that much less hot air, and if nothing else the council meetings would waste less time. The council protested that it would be too much trouble to get such a measure on the ballot by November's regular election day, and holding a special referendum would be a waste of the taxpayers' money.

In the end—actually, December 1998—the people voted and the council was cut down to size. The plastic cow remains upon her storied rooftop, though the convenience store is now a taco stand. And in 2001, a federal appeals court rejected the veterans' suit, ruling that a municipality is within its rights to decree that size does matter.

Yes, they were still talking about the flag.

And, yes, our town can be a loony bin. It doesn't have the nickname "Bull City" for nothing. But the outcome of the flag flap, et al, illustrates one important point. In Durham, you can fight city hall and win.

Durham, one citizen who knows the place well has said, is a town where anyone can call a meeting and people will show up. Another has said that Durham is a town where everything happens out in the open. Durham does have a way of airing its dirty laundry in public, but some of it at least gets aired; and through its history, what good things have come to pass in Durham—hospitals, public schools, public health, the library, the Eno River parks, letting some air out of a bloated city council—came about through private citizens' initiative and the fact that they cared enough about the place to overcome the all-American malaise of civic inertia.

Sure, you can't drive three stoplights in a row without getting stopped by at least one, and the streets run every which way except where you need to go—and might change names three times before you realize you should have left all hope at the city limits. We have two Five Points, one a confusing intersection and the other an open-air pharmaceutical exchange. Crime and poverty seem intractable. Housing's been an issue at least since 1940. And consultants' reports come and go like colds in kindergarten. However, all in all it's a fascinating, fun and inviting place to live and be a part of.

That's the thing about Durham: civic life is a participant sport and everybody's welcome to play. It can be messy, it can be downright silly, but it's as much a part of the community culture as the darkly comic boosterism that, way back in 1913, proclaimed Durham was "renowned the world

around" in 1,230 colored electric light bulbs from the top of a building. The "Slogan Sign" soon went down in a windstorm.

Durham has a sidewalk fiddler who once ran for the United States Senate and we used to have a panhandler who would give you a quarter if you didn't have one to give him. It's just that kind of a place.

When you are fifteen, it's downright crazy. When you are thirty-five or forty, you might think it absolutely outrageous. A few more years' perspective, it's merely foolish. The fact is, it's just our town being itself and would we really want it any other way? How dull.

Welcome home.

Please visit us at
www.historypress.net

Printed in the USA
CPSIA information can be obtained
at www.ICGtesting.com
LVHW061807011023
759810LV00009B/141